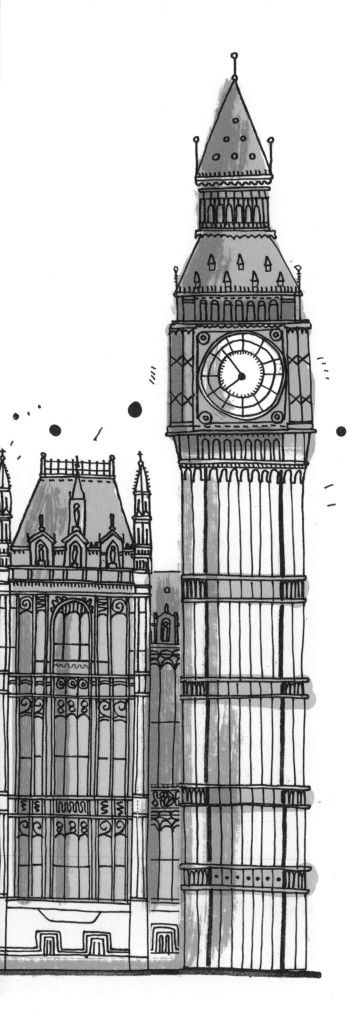

ALL THE BUILDINGS* IN LONDON

올 더 빌딩스 인 런던

제임스 걸리버 핸콕 지음 I 김문주 옮김

책/벌전소

런던의 모든 건물
회색 도시, 런던을 느끼다

나와 런던의 인연은 늘 묘했다. 내 어머니는 영국인이다. 그래서 우리는 친척을 만나기 위해 고향 시드니에서부터 영국까지 여행을 가곤 했다. 또 연말 휴가 때는 대부분 그곳에서 보냈다. 그때 영국의 겨울은 가장 어둡고 매서운 시기였다. 얇은 티셔츠와 반바지 차림으로 비행기에서 내려 오후 네 시부터 어두워지는 회색빛 하늘과 축축하고 헐벗은 나무들이 기다리는 땅에 발을 디디는 것은 정말 생경한 경험이었다. 시드니와 정반대에 있는 지구 저편에서 나는 우울하기보단 흥미로웠다.

그리고 곧 건축물에 주목했다. 사실 영국으로 떠난 첫 해외여행에서 나는 완전히 새로운 건축양식과 전통에 금방 빠져들었다. 이곳에는 완전히 다른 세계와 도시의 삶이 존재한다고 느꼈던 것이 기억난다. 시드니는 꽤 유기적으로 발달한 도시이다. 런던도 마찬가지이다. 그러나 런던은 시대적 요소를 품었는데, 로마 시대까지 거슬러 올라가는 힘이 있었다.

어른이 되어 처음으로 런던을 찾았을 때 나는 아주 오래된 런던 여행 안내서를 들고 있었다. 1900년대에 발간된 이 책에는 런던을 도보로 여행하는 방법이 담겼다. 나는 여러 차례에 걸쳐 순수하게 책만 의지해 도시를 탐험했다. 역사가 런던에 미친 영향력은 놀라울 정도였다. 그리고 역사를 통해 한 도시가 상대적으로 빠르게 변화하는 모습을 직접 경험한 것은 처음이었다. 나는 도심 한가운데를 걷기 시작하다 곧 깨달았다. 책에서 묘사된 대로 구불구불 난 도로는 그토록 오랜 시간이 지났음에도 그대로였다. 그러나 이제는 새로운 건축양식과 도시계획이 이를 넘보았다. 도보 여행에서 가장 강렬했던 경험은 한 공원에서 사라진 교회의 아름다움을 칭송한 글을 읽은 일이었다. 요즘 다큐멘터리에서 그렇듯 내 곁에는 상상의 교회가 입체 모형처럼 저절로 세워졌다. 제2차 세계대전 도중 파괴된 교회를 재건하지 않았을 것이란 생각이 문득 들었다. 학교에서 배웠던 전쟁과 유럽의 역사가 눈앞에 펼쳐지는 경험은 놀라울 뿐만 아니라 런던의 삶을 구성하는 요소로 내 머릿속을 떠나지 않았다.

또 다른 선명한 기억은 할아버지 댁에서 나는 냄새이다. 내가 아주

어렸을 적 맡았던 사과와 치즈의 향은 이제 희미하게 기억 속에 남아있다. 그리고 이는 잠재의식 속에 정서적이고도 강렬하게 남아 영국과 감각적인 관계를 만들어주었다. 런던으로 돌아올 때마다 내가 이 도시의 구조에 얼마나 영향을 받는지. 런던에는 누구도 부인할 수 없는 풍부한 역사가 존재하고, 이미 그 거리를 스쳐 지난 문명이 그대로 켜켜이 쌓여 향기를 풍긴다. 내 고향 시드니, 아니면 내가 정착한 뉴욕과 비교해 런던은 여러 시대에 걸친 인간 활동이 그대로 풍성히 쌓인 것처

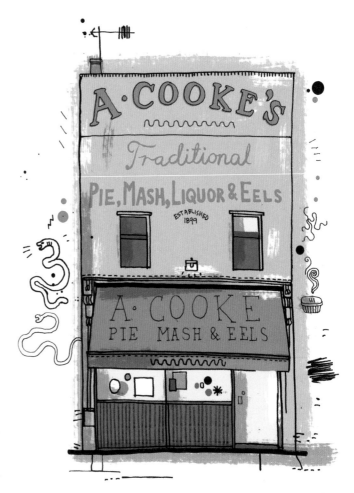

럼 보인다. 마치 양파처럼 껍질을 벗겨내면 그 역사를 한 겹 한 겹 떼어낼 수 있을 것만 같다.

나이가 든 후 처음으로 여름의 런던을 겪었을 때 나는 거의 충격으로 쓰러질 지경이었다. 그리고 의식적으로 그 여름의 세밀한 순간과 문화를 받아들였다. 여기저기서 수선화는 피어오르고 공유지에 무성하게 핀 소박한 꽃들은 거의 잔디처럼 취급되었다. 나는 사람들로 붐비던 하이드 파크에서 수선화를 본 기억이 난다. 어머니는 호주의 뜨거운 태양 아래서 수선화를 참 정성스레 가꾸었다. 이곳에선 한가득 핀 수선화가 그다지 귀하지 않았고 여기저기 쉽사리 피어있었다. 아무도 수선화를 눈여겨보지 않았고 무심히 짓밟았다.

나는 어른이 된 후 여러 시기에 런던에서 살았다. 맨 처음 런던에서 살았을 때, 이모와 함께 머물며 파이와 으깬 감자를 파는 작은 동네 가게에서 피클 액에 절인 삶은 달걀을 사 오던 기억이 난다. 새로운 음식은 호기심을 자극했지만 나는 달걀과 장어 젤리를 보고 움찔했다. 그러나 이 파격적인 음식에 본능적으로 흥미를 느꼈고, 특히 치즈를 먹을 때 가장 행복했다. 몇 년 동안이나 나는 뜬금없는 상황에서 영국 음식과 성글은 인연을 맺었지만 이제는 먹을 때면 뼛속 깊이 전율을 느낀다.

이러한 전형적인 '영국다움'과 마찬가지로 런던의 건축은 비슷비슷한 괴팍함과 강렬한 대조로 가득하다. 런던 전역의 다양한 장소에 머물면서 나는 그 다양한 특징을 알게 되었다. 그리고 건축물이 지닌 독특한 구조와 어우러지는 방식을 눈여겨보며 교감을 쌓았다. 나는 불쑥 튀어나온 목제 건물 사이를 누비며 고대의 좁은 골목길에, 주요 랜드마크에, 그리고 새로 지은 건축물에 흠뻑 빠져버렸다. 오랜 도시가 새로운 건축물을 포용하고 함께 어울리는 모습은 경이로울 따름이었다.

이 책은 내 개인적 관점을 통해 세계 곳곳 다양한 도시 속 건축을 탐험하는 시리즈 가운데 하나이며 경험을 그림으로 표현한 일기이다. 보통 나는 건축물 앞에서나 찍어온 사진을 보면서 그린다. 그리고 단순한 스케치북 위에 기본 펜과 연필을 이용해 작업하기를 좋아한다. 나는 자전거 타기를 아주 좋아하기 때문에 보통은 그러한 시점에서 장소를 경험한다. 즉, 두 바퀴를 굴리며 도시를 미끄러져 나가다가 매력을 느끼는 장소를 발견하면 멈춰서 그림을 그린다. 이러한 프로젝트는 특정 주제로 한 그림 위주의 내 스케치북과 마찬가지로, 집착하는 대상에 대한 기본적인 흥미에서 시작했다. 예를 들어 이 건축물 드로잉(이는 그 자체로 컬렉션이다)에는 그와 동시에 경험할 수 있는 일을 함께 곁들인다. 마치 진짜 일기처럼 그런 곁들임은 내게 친근감과 개성을 한 겹 더해주는 셈이다. 그런 곁들임이 없다 하더라도 그저 주변에 있는 사물을 그리기 위해 멈추는 일은 그 장소에 대한 새로운 감각을 안겨준다. 한 장소를 구성하는 조각조각에 초점을 맞출 때 미처 주목하지 못

한 새로운 면을 끄집어낼 수 있다. 나는 당신이 쳇바퀴 같은 일상에서 한 발자국 물러나 주변의 세세한 부분에 좀 더 시간을 들였으면 한다. 익숙한 무엇인가를 그림으로 볼 때 당신은 그 장소에 다시 한번 관심을 기울일 것이다. 또한 이는 지금껏 경험하지 못한 유대감으로 이어진다.

내가 사는 뉴욕과 완전히 다른 도시인 런던을 그리는 일은 재미있었다. 역사적인 골목과 도로를 따라 만들어지는 구불구불한 선은 애초에 다른 종류의 생생한 표현을 만들어냈다. 뉴욕은 너무나 강렬하게 일직선으로 뻗었지만 런던은 너무나 맛깔스러우면서도 불안정하고 유기적이다.

나는 당신이 평생 런던에서 산 토박이든 새로운 방문자이든 간에 이 책을 즐길 수 있길, 그래서 런던과 사랑에 빠지길 바란다. 이 책은 내 두 눈으로 본 런던이자 당신의 여행을 돕기 위한 개인 여정의 기록이다. 더 많은 그림은 개인 블로그(www.allthebuildingsinlondon.com)에서 만나볼 수 있다.

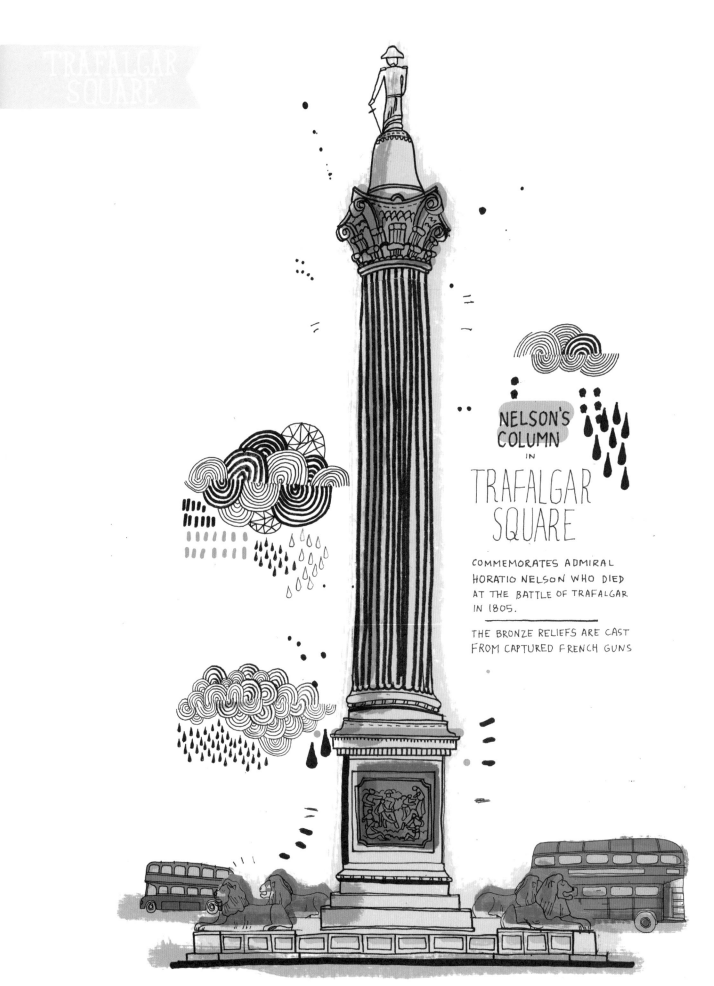

NELSON'S COLUMN
IN
TRAFALGAR SQUARE

COMMEMORATES ADMIRAL
HORATIO NELSON WHO DIED
AT THE BATTLE OF TRAFALGAR
IN 1805.

THE BRONZE RELIEFS ARE CAST
FROM CAPTURED FRENCH GUNS

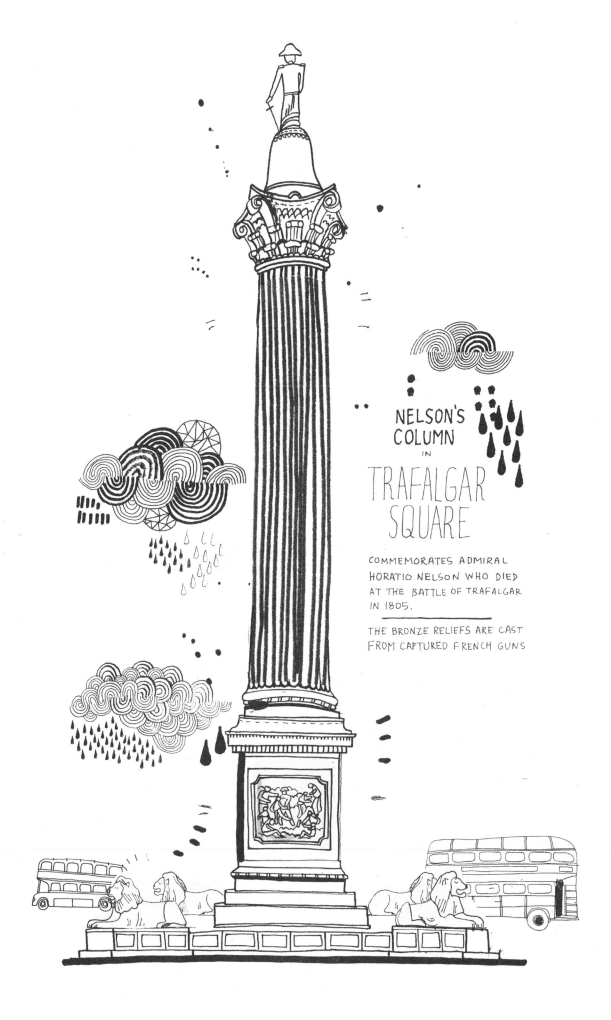

NELSON'S
COLUMN
IN
TRAFALGAR
SQUARE

COMMEMORATES ADMIRAL
HORATIO NELSON WHO DIED
AT THE BATTLE OF TRAFALGAR
IN 1805.

THE BRONZE RELIEFS ARE CAST
FROM CAPTURED FRENCH GUNS

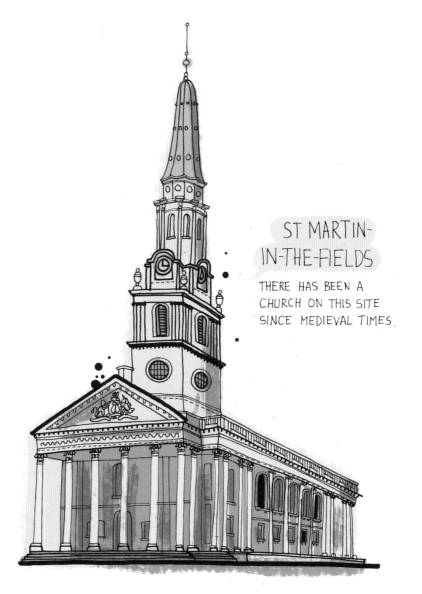

ST MARTIN-IN-THE-FIELDS

THERE HAS BEEN A CHURCH ON THIS SITE SINCE MEDIEVAL TIMES.

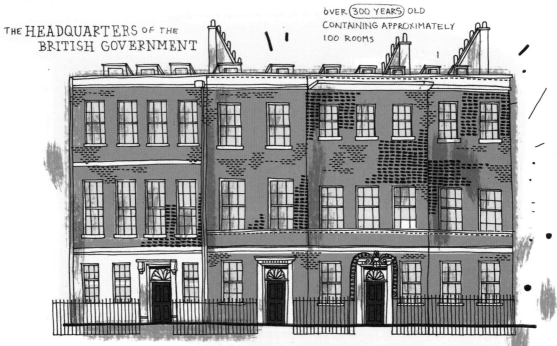

THE HEADQUARTERS OF THE BRITISH GOVERNMENT

OVER (300 YEARS) OLD CONTAINING APPROXIMATELY 100 ROOMS

10 DOWNING ST.

THE DOOR CANNOT BE OPENED FROM THE OUTSIDE

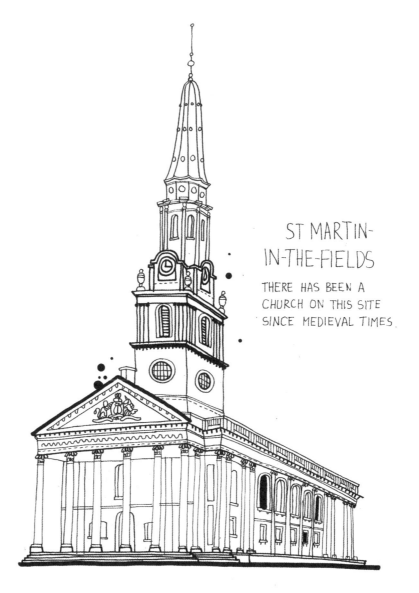

ST MARTIN-
IN-THE-FIELDS

THERE HAS BEEN A
CHURCH ON THIS SITE
SINCE MEDIEVAL TIMES.

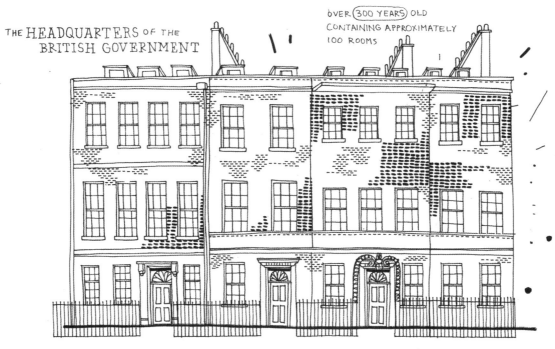

THE HEADQUARTERS OF THE
BRITISH GOVERNMENT

OVER 300 YEARS OLD
CONTAINING APPROXIMATELY
100 ROOMS

10 DOWNING ST.

THE DOOR CANNOT BE
OPENED FROM
THE OUTSIDE

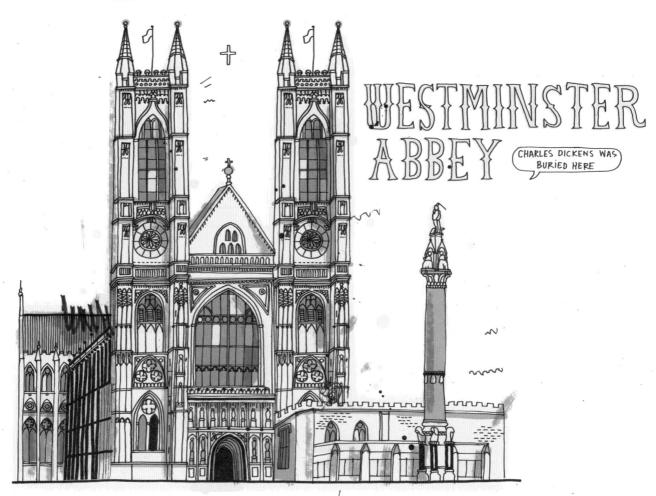

WESTMINSTER ABBEY

CHARLES DICKENS WAS BURIED HERE

KEEPS GOING!

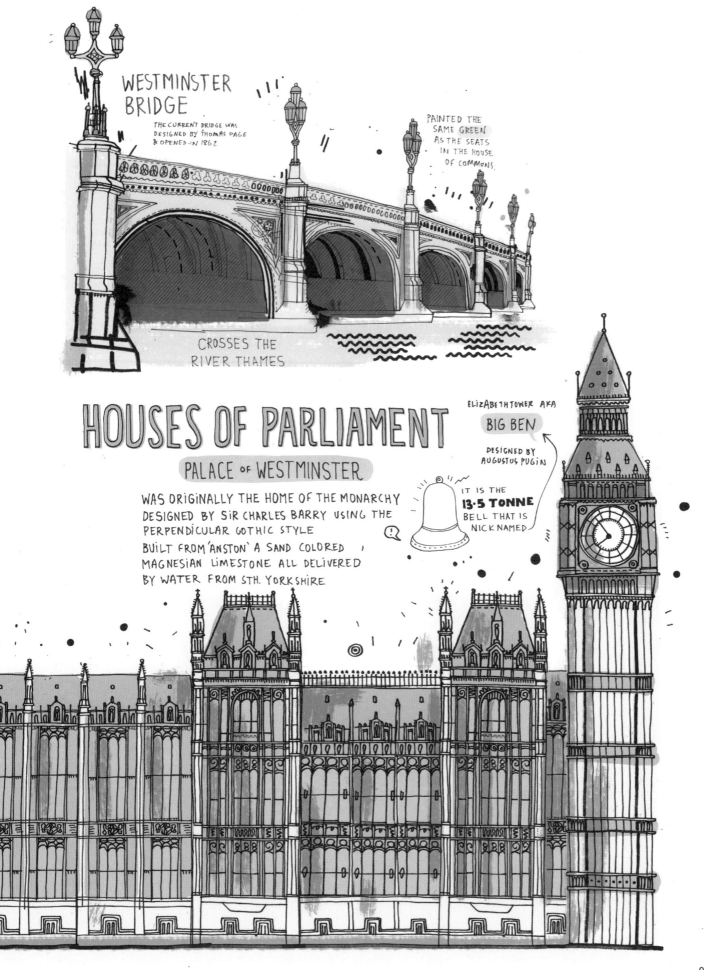

WESTMINSTER BRIDGE

THE CURRENT BRIDGE WAS DESIGNED BY THOMAS PAGE & OPENED IN 1862

PAINTED THE SAME GREEN AS THE SEATS IN THE HOUSE OF COMMONS

CROSSES THE RIVER THAMES

HOUSES OF PARLIAMENT

PALACE of WESTMINSTER

WAS ORIGINALLY THE HOME OF THE MONARCHY DESIGNED BY SIR CHARLES BARRY USING THE PERPENDICULAR GOTHIC STYLE
BUILT FROM 'ANSTON' A SAND COLORED MAGNESIAN LIMESTONE ALL DELIVERED BY WATER FROM STH. YORKSHIRE

ELIZABETH TOWER AKA
BIG BEN

DESIGNED BY AUGUSTUS PUGIN

IT IS THE **13·5 TONNE** BELL THAT IS NICKNAMED

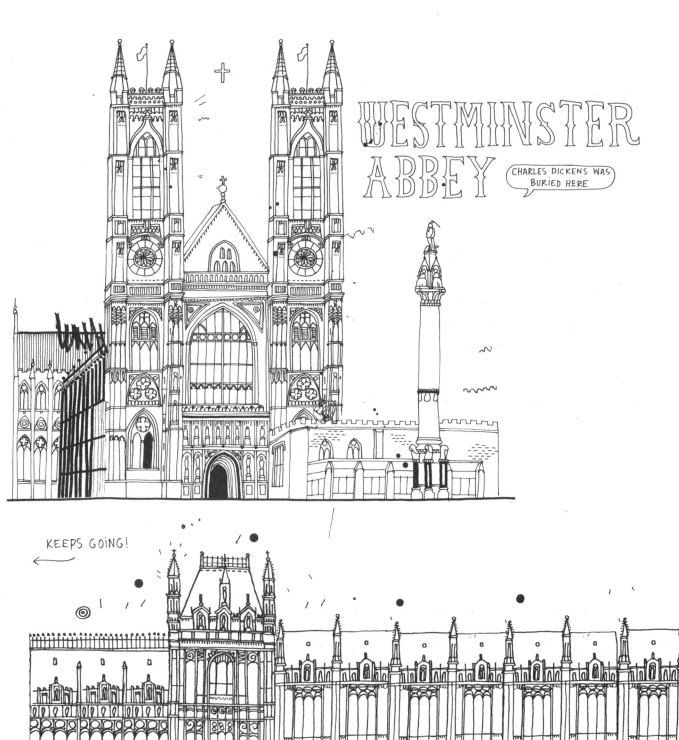

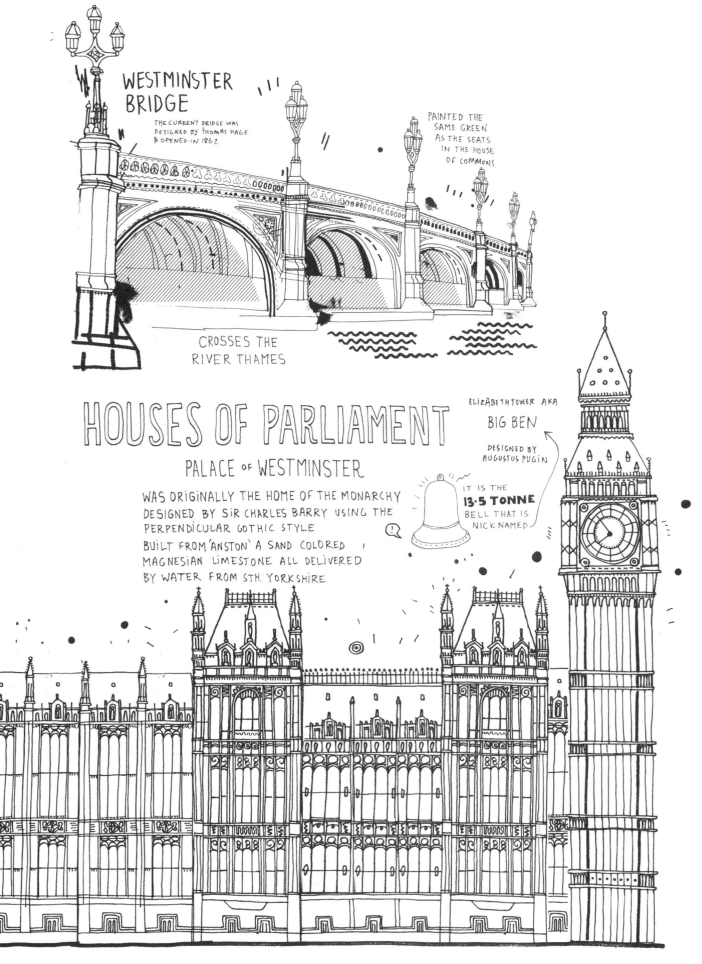

WESTMINSTER BRIDGE

THE CURRENT BRIDGE WAS DESIGNED BY THOMAS PAGE & OPENED IN 1862

PAINTED THE SAME GREEN AS THE SEATS IN THE HOUSE OF COMMONS.

CROSSES THE RIVER THAMES

HOUSES OF PARLIAMENT

PALACE of WESTMINSTER

WAS ORIGINALLY THE HOME OF THE MONARCHY
DESIGNED BY SIR CHARLES BARRY USING THE
PERPENDICULAR GOTHIC STYLE
BUILT FROM 'ANSTON' A SAND COLORED
MAGNESIAN LIMESTONE ALL DELIVERED
BY WATER FROM STH. YORKSHIRE

ELIZABETH TOWER AKA **BIG BEN**

DESIGNED BY AUGUSTUS PUGIN

IT IS THE **13·5 TONNE** BELL THAT IS NICKNAMED

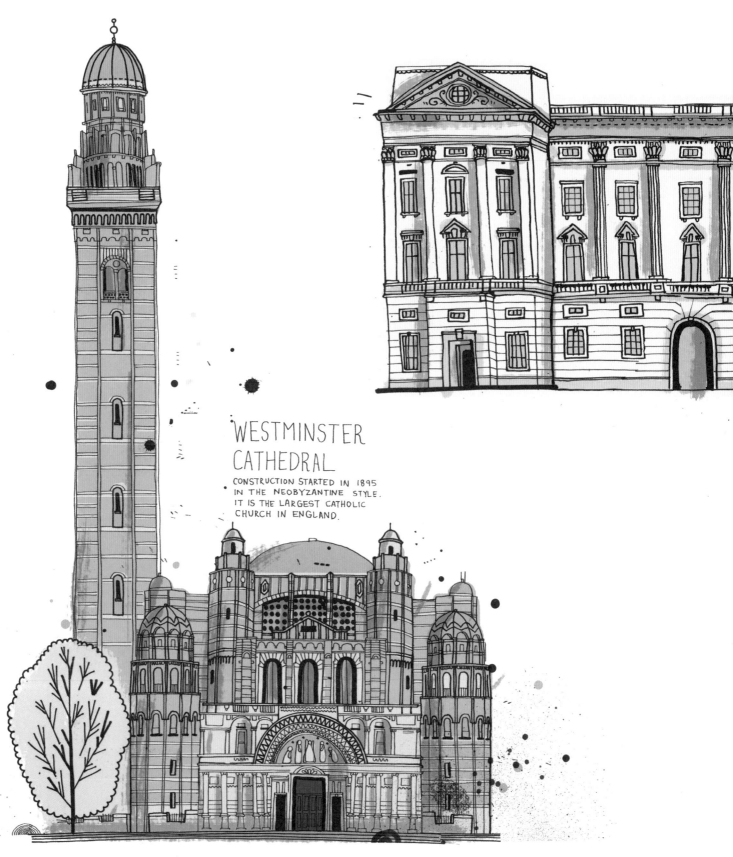

WESTMINSTER CATHEDRAL

CONSTRUCTION STARTED IN 1895
IN THE NEOBYZANTINE STYLE.
IT IS THE LARGEST CATHOLIC
CHURCH IN ENGLAND.

BUCKINGHAM PALACE

QUEEN VICTORIA WAS THE FIRST MONARCH TO TAKE UP RESIDENCE IN 1837.

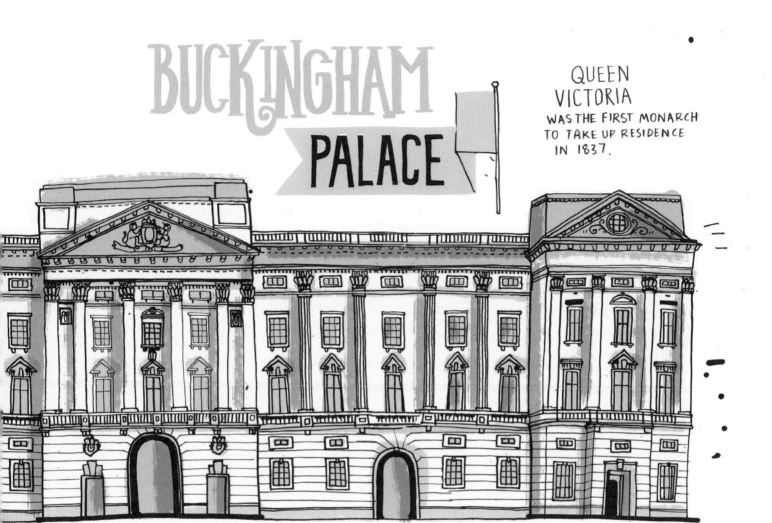

KINNERTON STREET

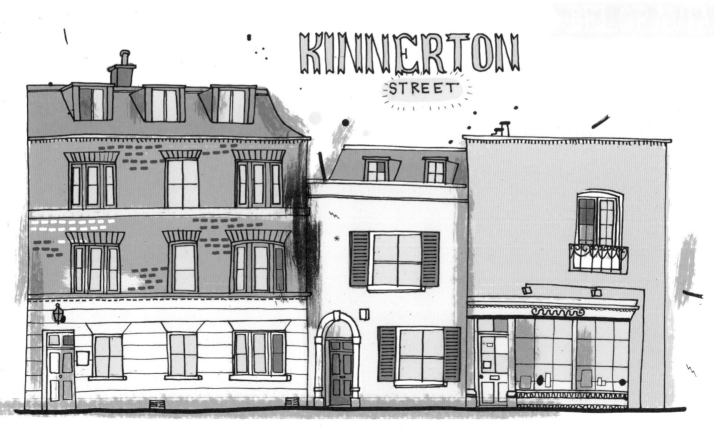

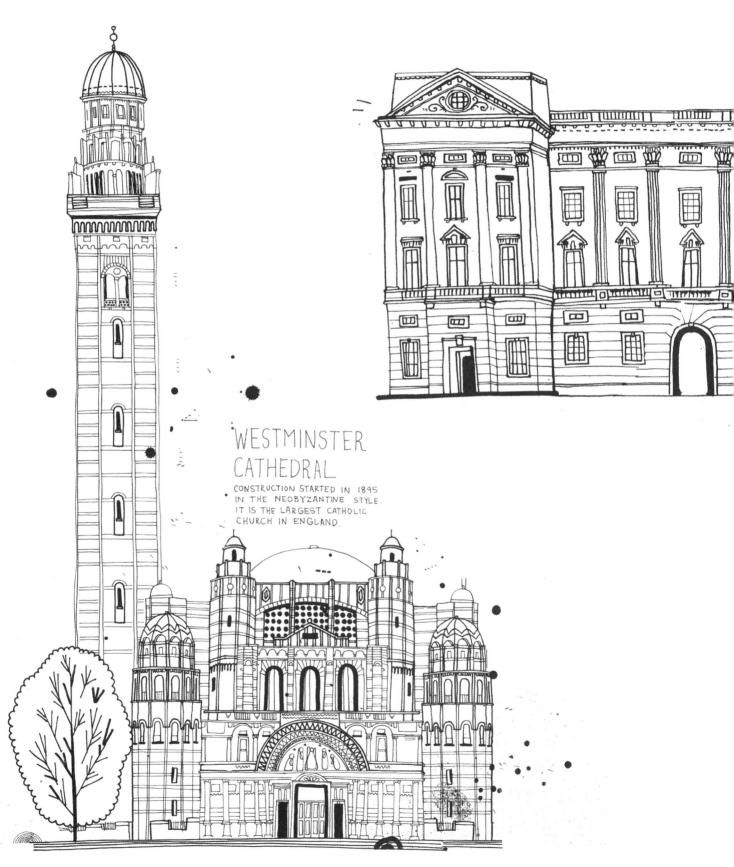

WESTMINSTER CATHEDRAL

CONSTRUCTION STARTED IN 1895
IN THE NEOBYZANTINE STYLE.
IT IS THE LARGEST CATHOLIC
CHURCH IN ENGLAND.

BUCKINGHAM PALACE

QUEEN VICTORIA WAS THE FIRST MONARCH TO TAKE UP RESIDENCE IN 1837.

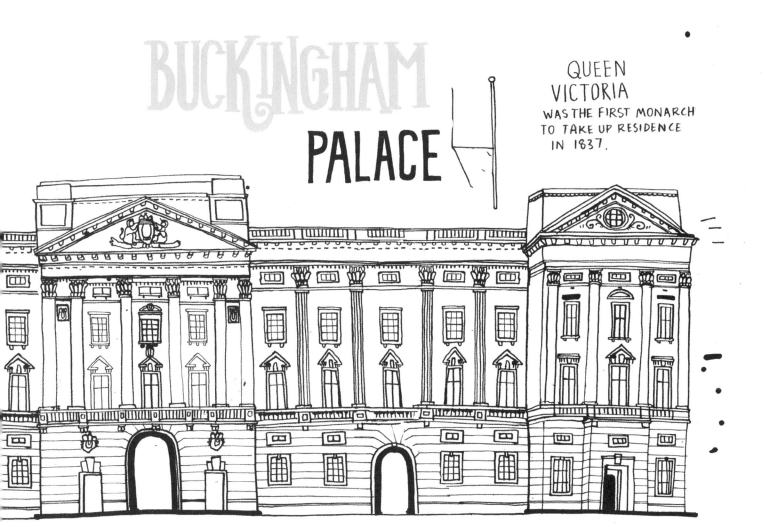

KINNERTON STREET

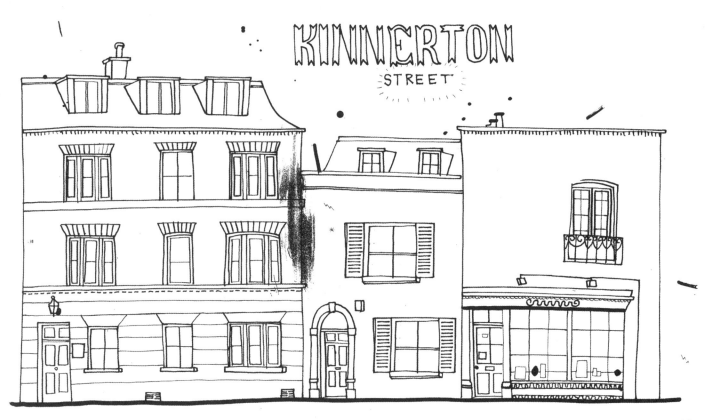

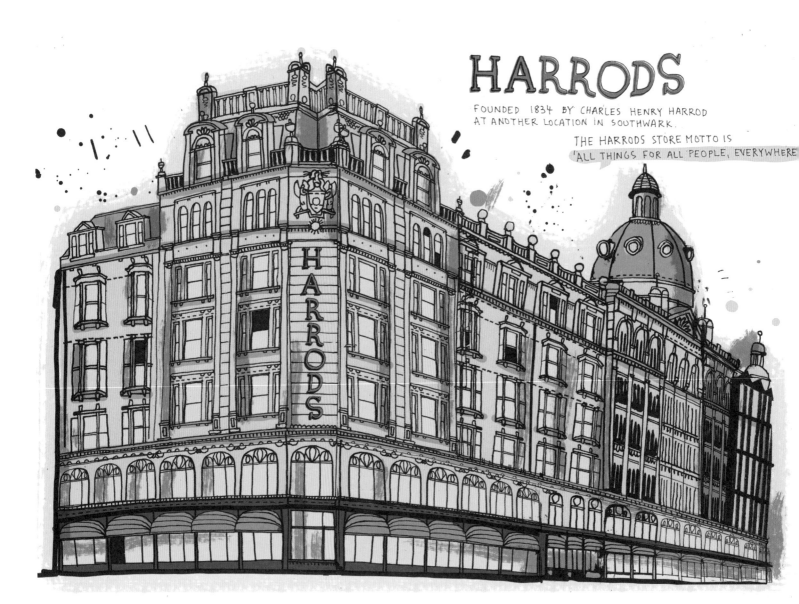

HARRODS

FOUNDED 1834 BY CHARLES HENRY HARROD
AT ANOTHER LOCATION IN SOUTHWARK.

THE HARRODS STORE MOTTO IS
'ALL THINGS FOR ALL PEOPLE, EVERYWHERE

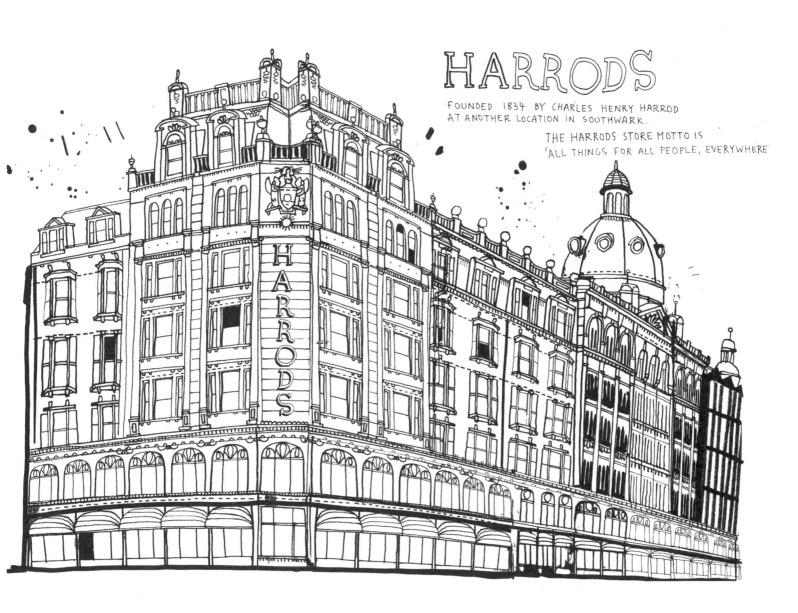

HARRODS

FOUNDED 1834 BY CHARLES HENRY HARROD
AT ANOTHER LOCATION IN SOUTHWARK.

THE HARRODS STORE MOTTO IS
'ALL THINGS FOR ALL PEOPLE, EVERYWHERE'

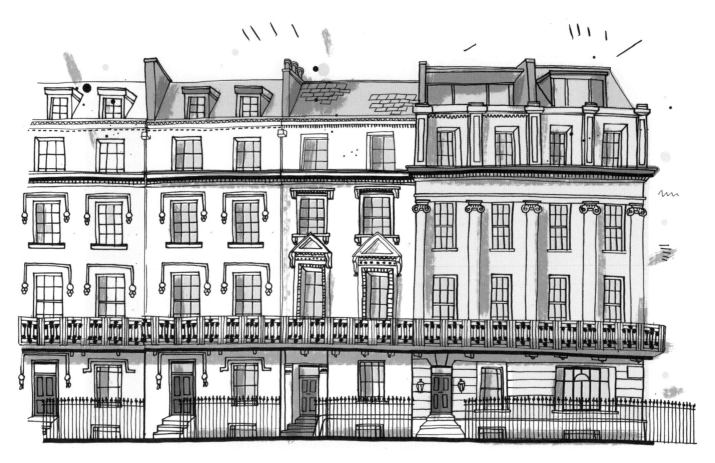

MONTPELIER SQ.

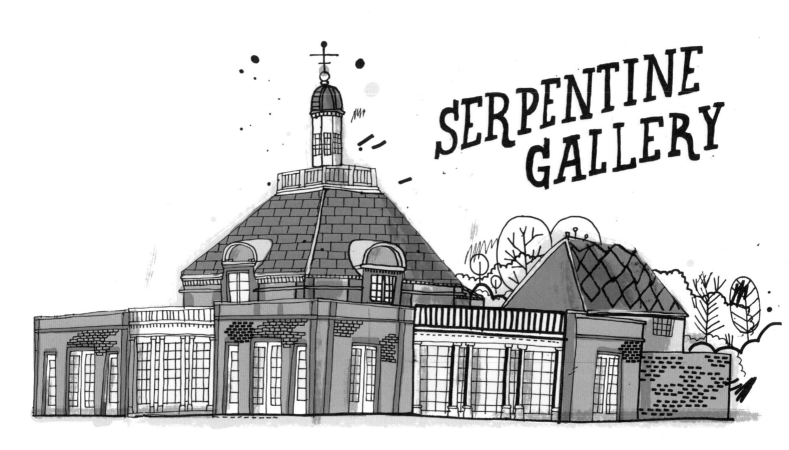

SERPENTINE GALLERY

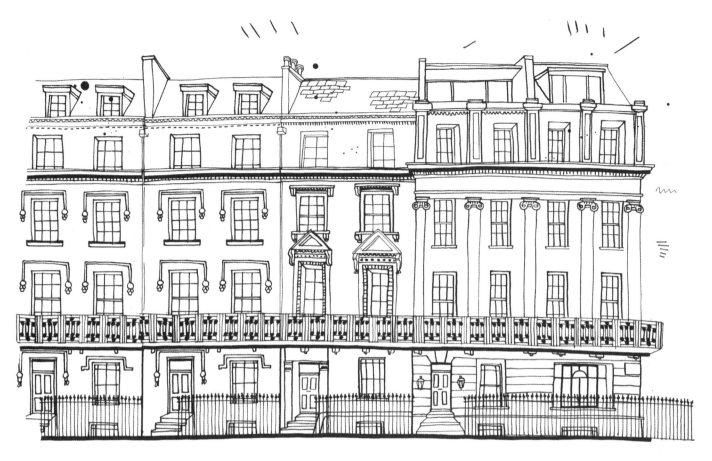

MONTPELIER SQ.

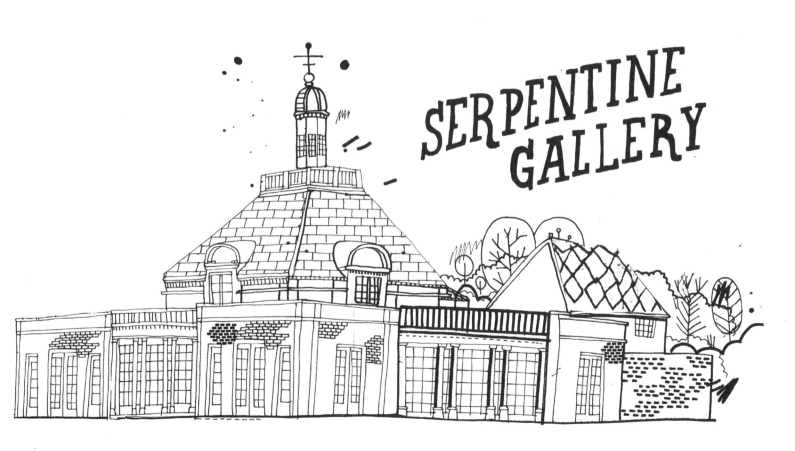

SERPENTINE GALLERY

ROYAL ALBERT HALL

AROUND THE OUTSIDE OF THE ELLIPTICAL BUILDING IS A HUGE MOSAIC DEPICTING

"THE ADVANCEMENT OF THE ARTS AND SCIENCES"

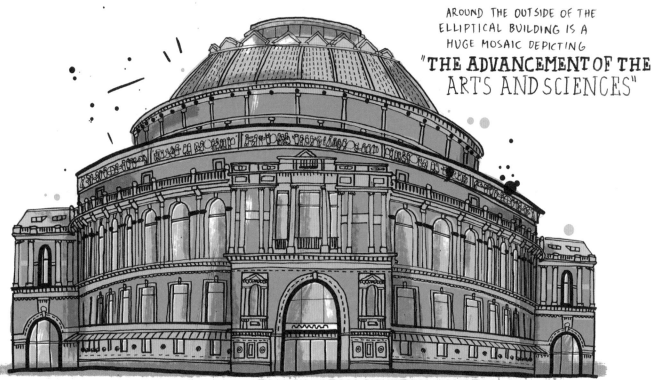

THE ALBERT MEMORIAL IS JUST ACROSS THE ROAD, BOTH BEING DEDICATED TO QUEEN VICTORIA'S BELOVED HUSBAND PRINCE ALBERT

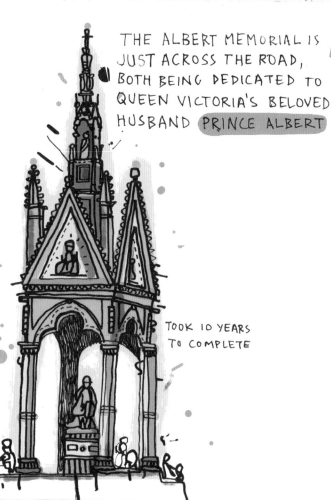

TOOK 10 YEARS TO COMPLETE

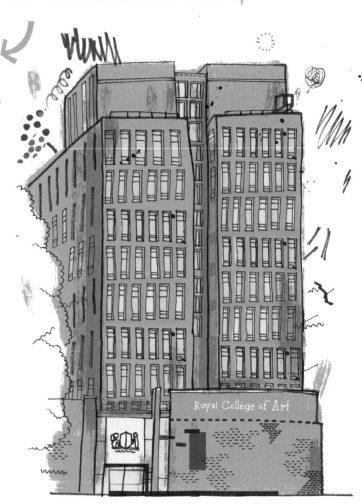

Royal College of Art

AROUND THE OUTSIDE OF THE ELLIPTICAL BUILDING IS A HUGE MOSAIC DEPICTING **"THE ADVANCEMENT OF THE ARTS AND SCIENCES"**

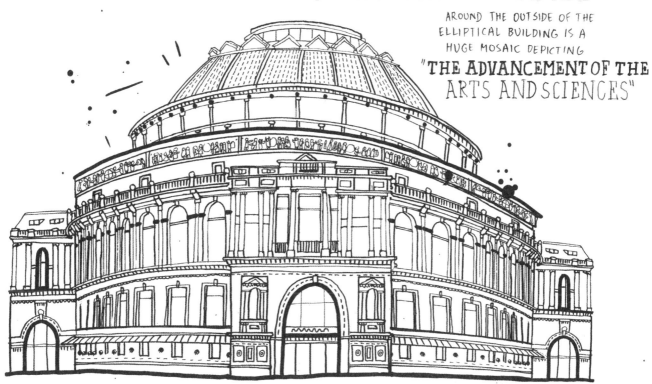

THE ALBERT MEMORIAL IS JUST ACROSS THE ROAD, BOTH BEING DEDICATED TO QUEEN VICTORIA'S BELOVED HUSBAND PRINCE ALBERT

TOOK 10 YEARS TO COMPLETE

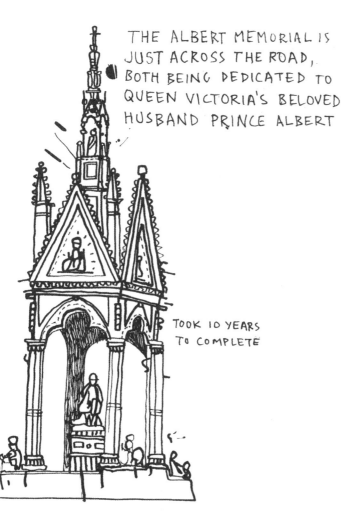

MAIN ENTRANCE
OF THE

VICTORIA
&
ALBERT
MUSEUM

THE WORLD'S LARGEST
MUSEUM OF
DECORATIVE ARTS
COVERING 5000
YEARS OF ART
OVER 12.5 ACRES

MAIN ENTRANCE
OF THE

VICTORIA
&
ALBERT
MUSEUM

THE WORLD'S LARGEST
MUSEUM OF
DECORATIVE ARTS
COVERING 5000
YEARS OF ART
OVER 12.5 ACRES

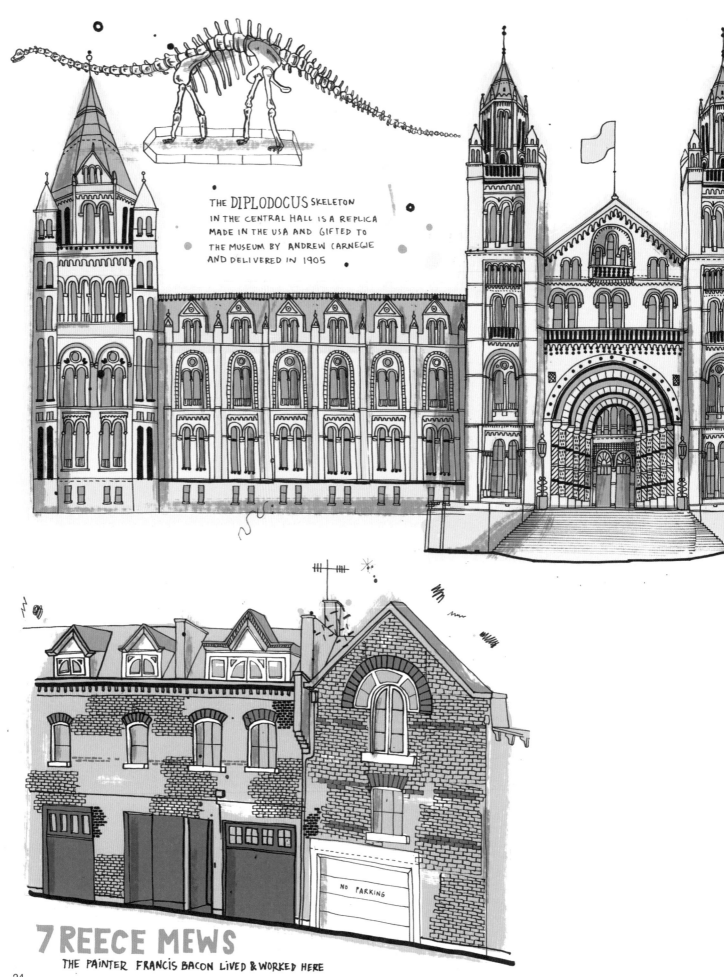

THE **DIPLODOCUS** SKELETON
IN THE CENTRAL HALL IS A REPLICA
MADE IN THE USA AND GIFTED TO
THE MUSEUM BY ANDREW CARNEGIE
AND DELIVERED IN 1905

NO PARKING

7 REECE MEWS
THE PAINTER FRANCIS BACON LIVED & WORKED HERE

THE Natural History MUSEUM

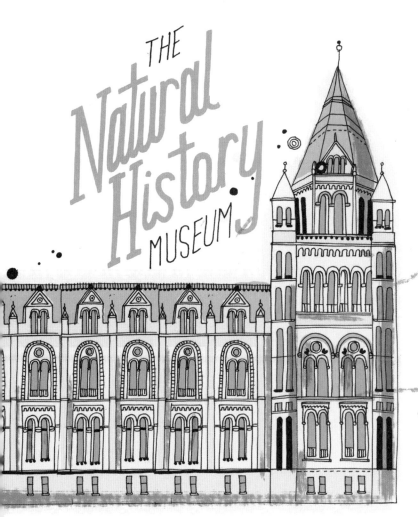

DESIGNED & BUILT IN 1881
BY ALFRED WATERHOUSE

HOLDS AROUND
80 MILLION ITEMS
RELATING TO BOTANY, ENTOMOLOGY, MINEROLOGY,
PALEONTOLOGY & ZOOLOGY.

SOUTH·END

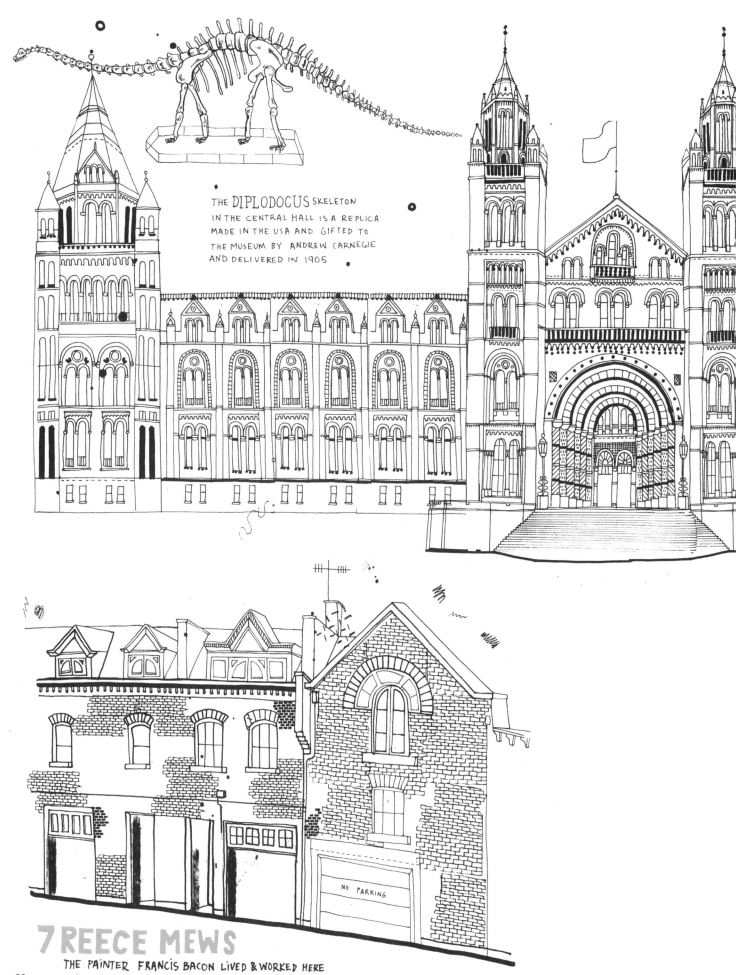

THE DIPLODOCUS SKELETON
IN THE CENTRAL HALL IS A REPLICA
MADE IN THE USA AND GIFTED TO
THE MUSEUM BY ANDREW CARNEGIE
AND DELIVERED IN 1905

NO PARKING

7 REECE MEWS
THE PAINTER FRANCIS BACON LIVED & WORKED HERE

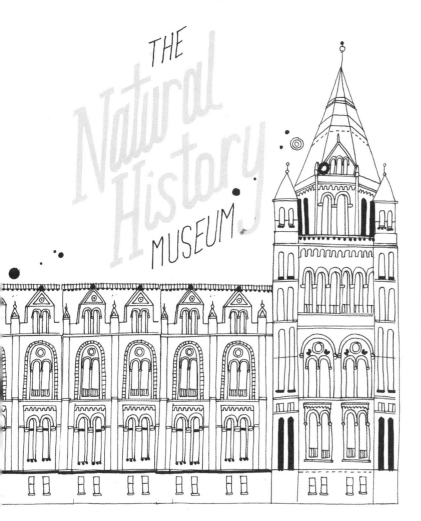

THE *Natural History* MUSEUM

DESIGNED & BUILT IN 1881
BY ALFRED WATERHOUSE

HOLDS AROUND
80 MILLION ITEMS
RELATING TO BOTANY, ENTOMOLOGY, MINEROLOGY, PALEONTOLOGY & ZOOLOGY.

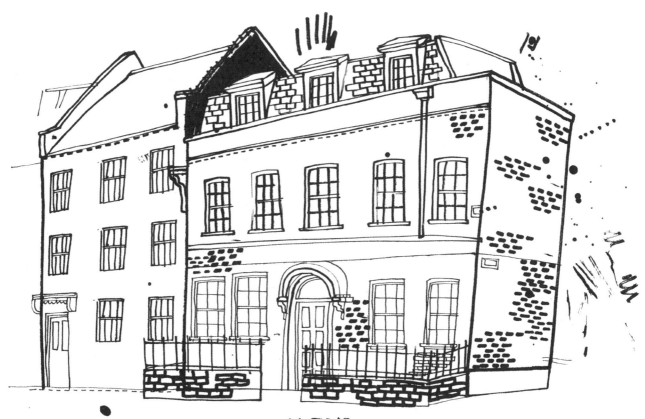

SOUTH·END

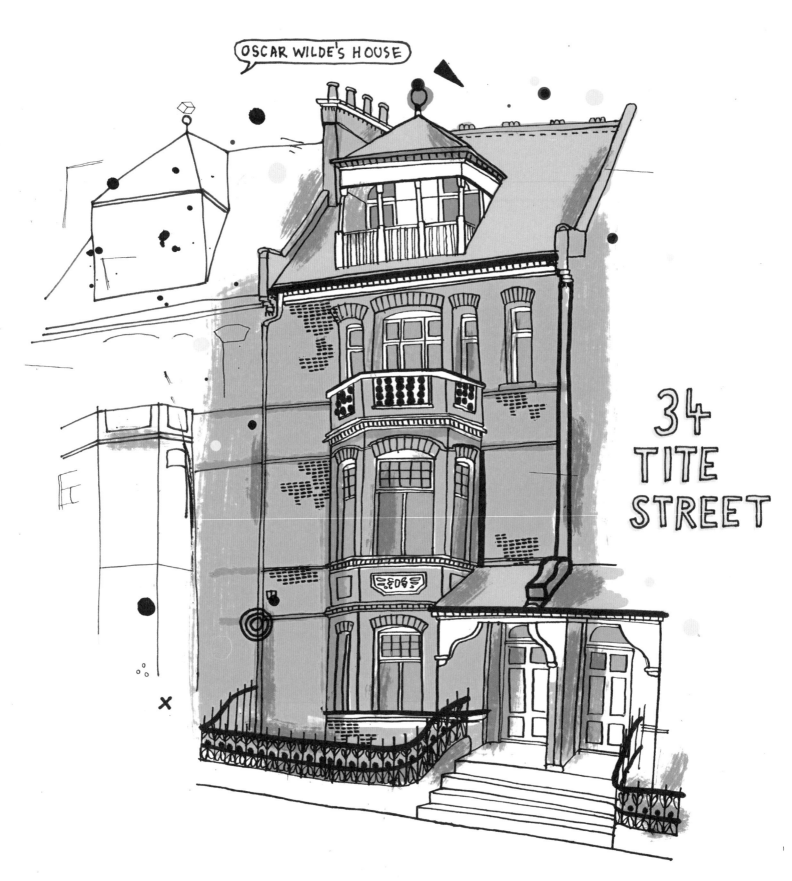

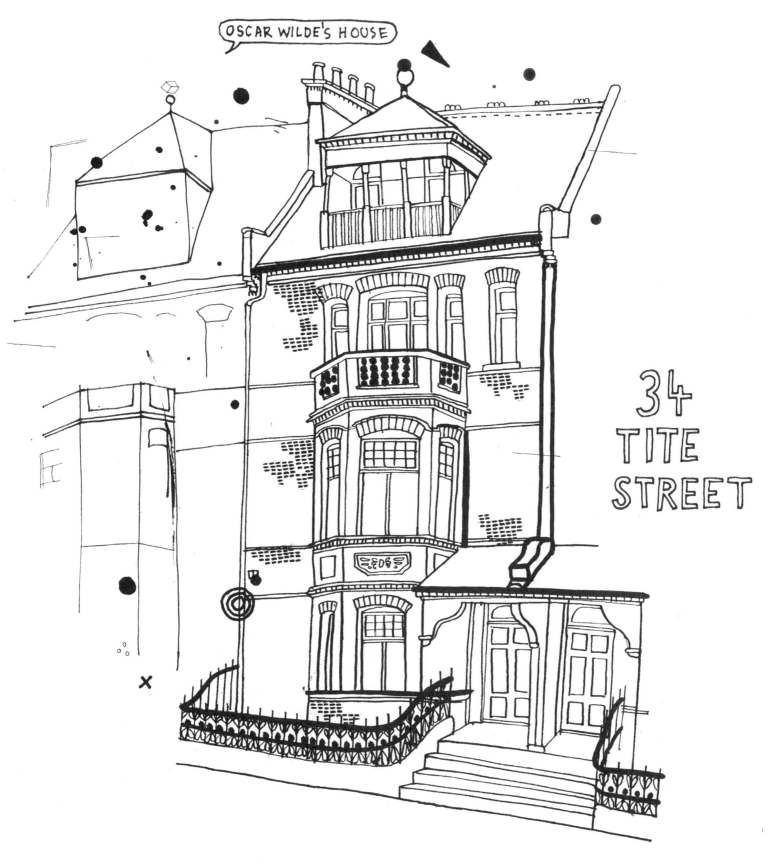

MICHELIN HOUSE
81 FULHAM ROAD

DESIGNED BY MICHELIN EMPLOYEE FRANCOIS ESPINASSE
AND HAS 3 LARGE STAINED GLASS WINDOWS
FEATURING THE MICHELIN MAN "BI BEN DUM"

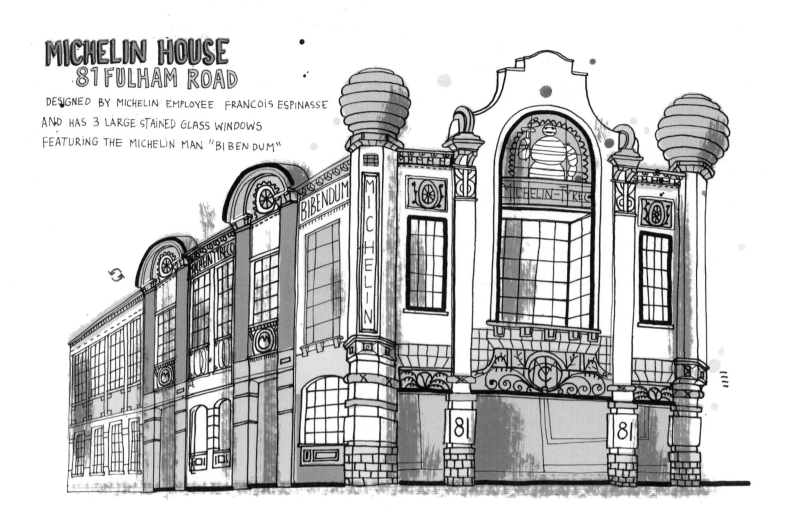

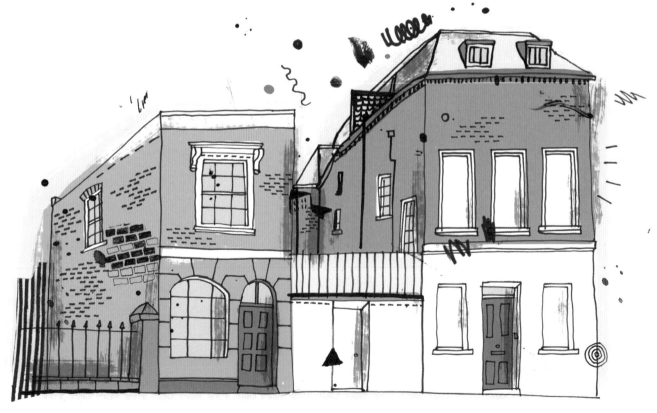

20 BRITTEN ST

MICHELIN HOUSE
81 FULHAM ROAD

DESIGNED BY MICHELIN EMPLOYEE FRANÇOIS ESPINASSE
AND HAS 3 LARGE STAINED GLASS WINDOWS
FEATURING THE MICHELIN MAN "BIBENDUM"

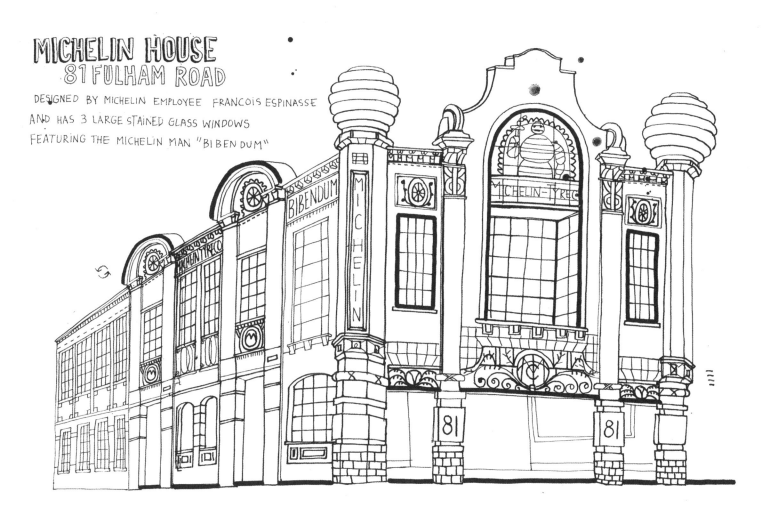

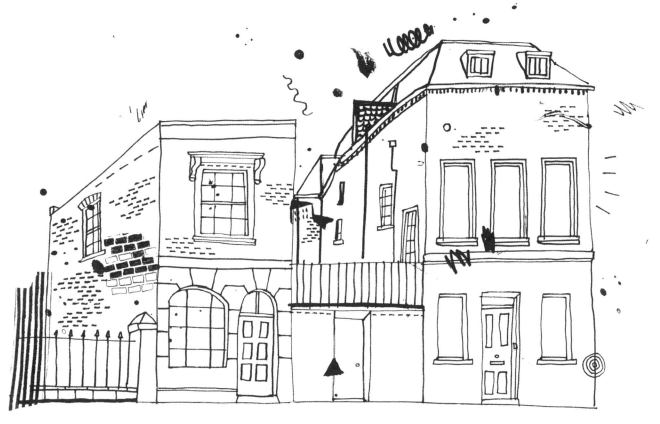

20 BRITTEN ST

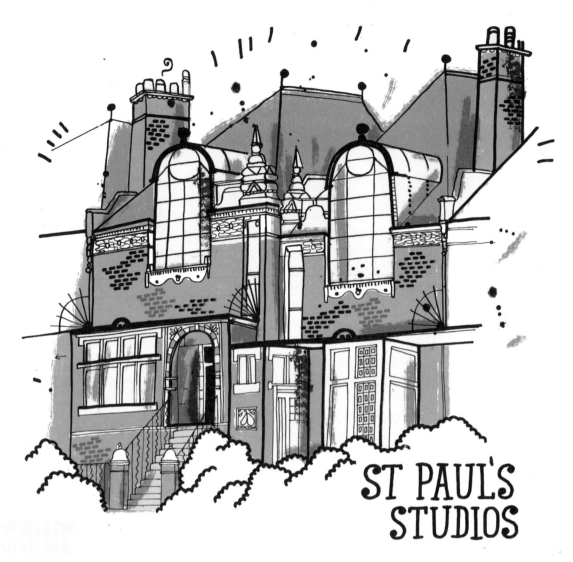

ST PAUL'S STUDIOS

PALM HOUSE

KEW GARDENS

THE FIRST LARGE SCALE
STRUCTURAL USE OF
WROUGHT IRON. THE GLASS
PANELS ARE ALL BLOWN
BY HAND.

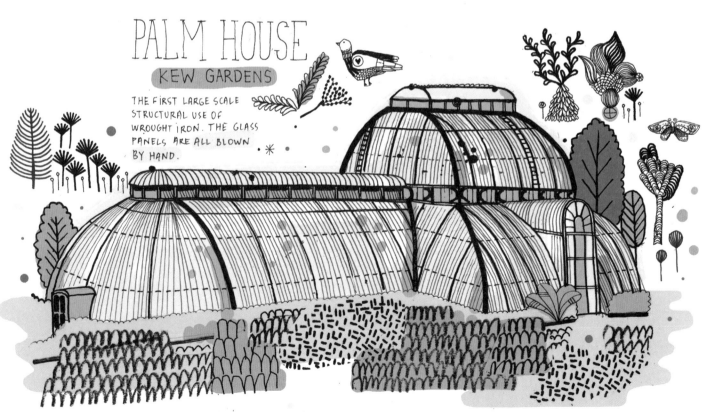

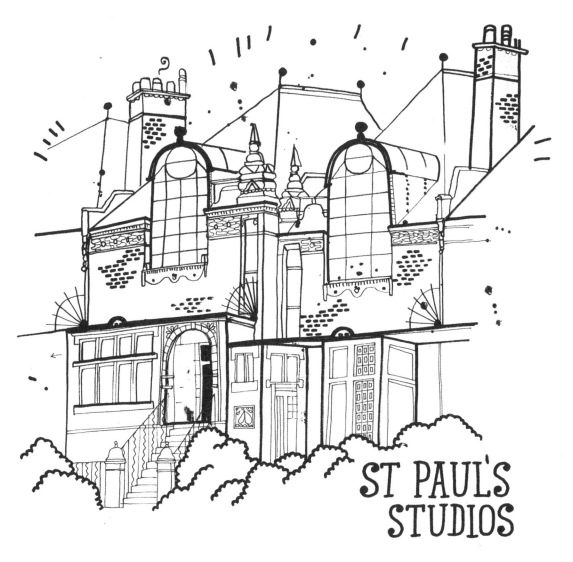

ST PAUL'S
STUDIOS

PALM HOUSE
KEW GARDENS

THE FIRST LARGE SCALE
STRUCTURAL USE OF
WROUGHT IRON. THE GLASS
PANELS ARE ALL BLOWN
BY HAND.

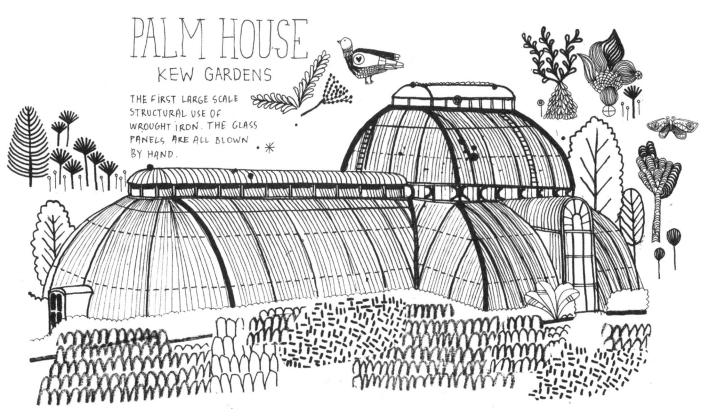

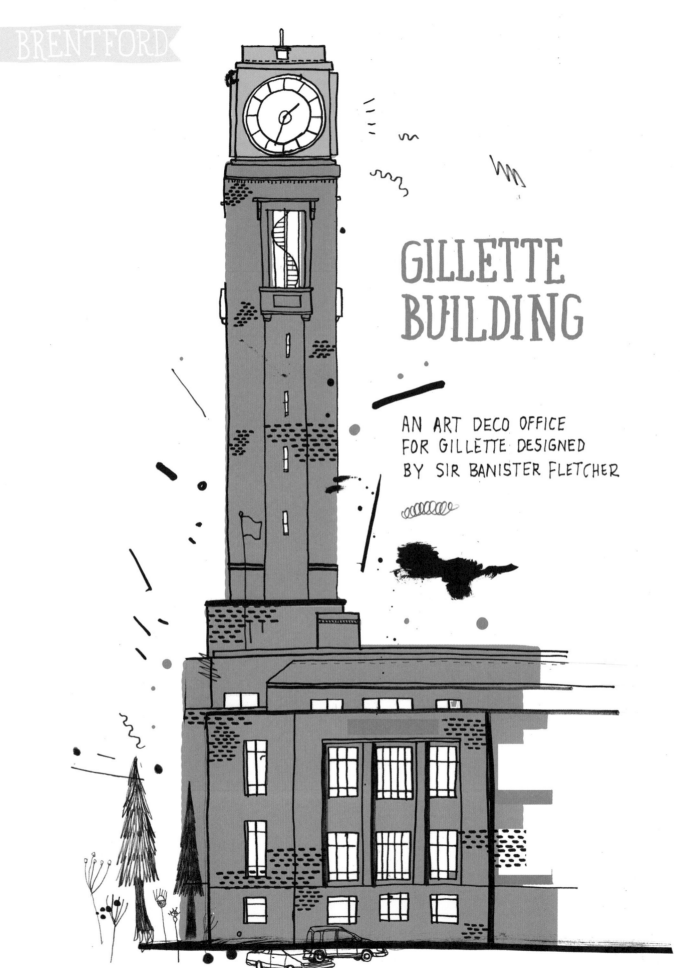

GILLETTE BUILDING

AN ART DECO OFFICE
FOR GILLETTE DESIGNED
BY SIR BANISTER FLETCHER

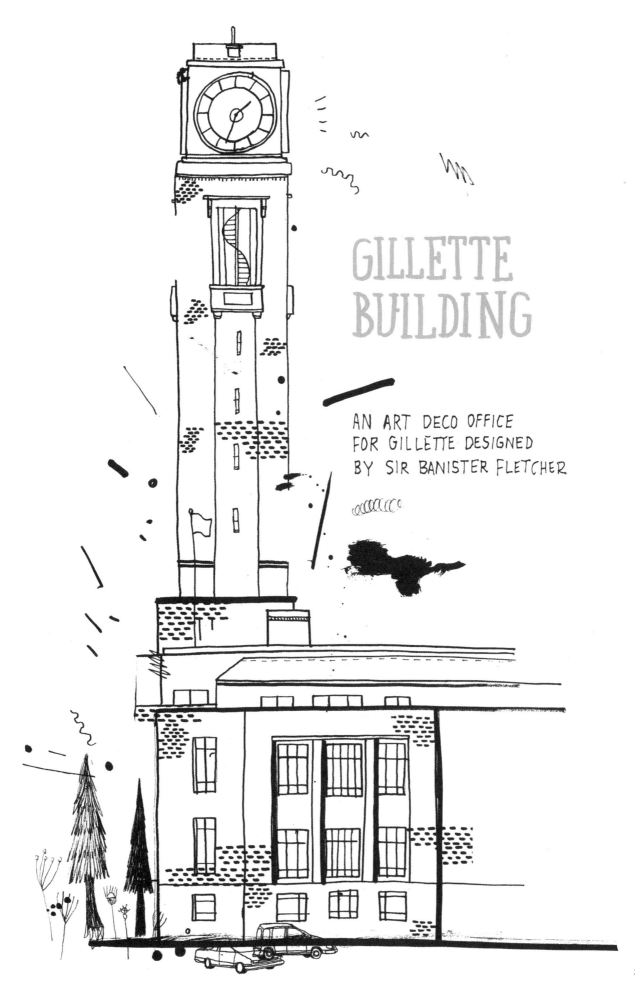

GILLETTE BUILDING

AN ART DECO OFFICE
FOR GILLETTE DESIGNED
BY SIR BANISTER FLETCHER

HOOVER
BUILDING

WESTERN AVENUE, PERIVALE

AN ART DECO MASTERPIECE!

BUILT IN 1933 FOR HOOVER CO.
IT BUILT ELECTRICS FOR PLANES
& TANKS IN WW2.

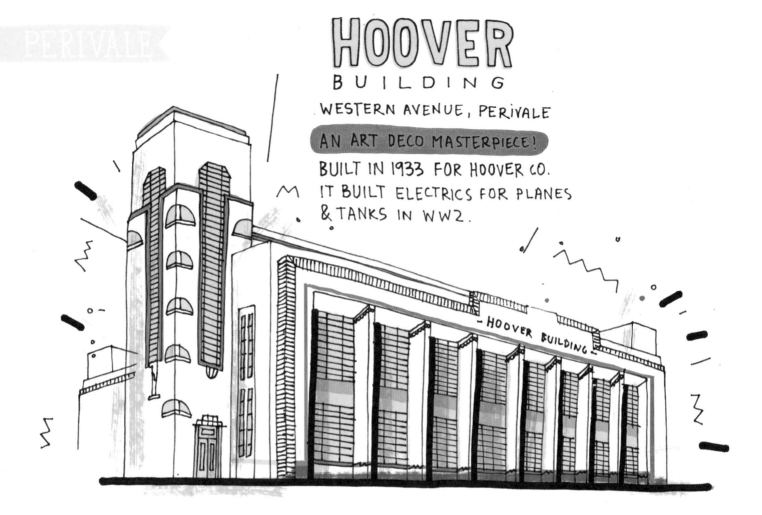

HOOVER BUILDING

OLIPHANT ST.

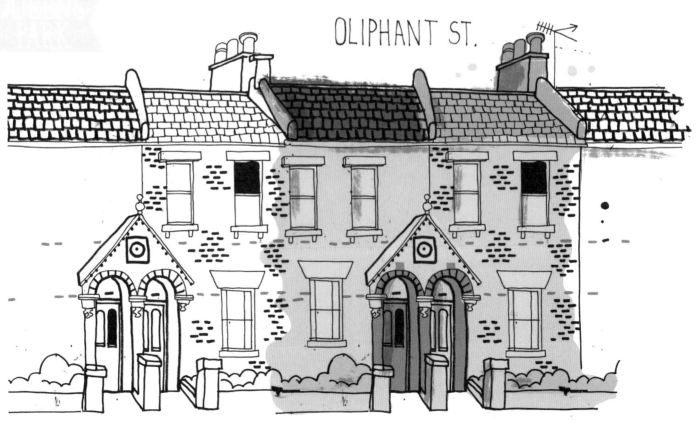

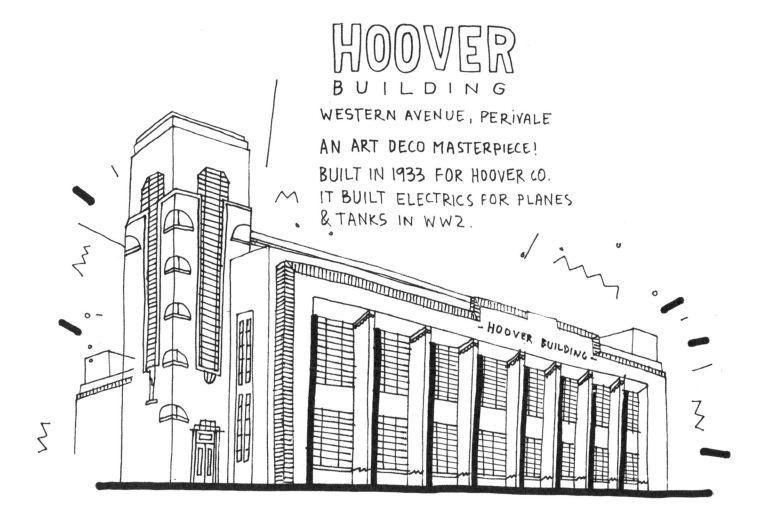

HOOVER
BUILDING

WESTERN AVENUE, PERIVALE

AN ART DECO MASTERPIECE!
BUILT IN 1933 FOR HOOVER CO.
IT BUILT ELECTRICS FOR PLANES
& TANKS IN WW2.

- HOOVER BUILDING -

OLIPHANT ST.

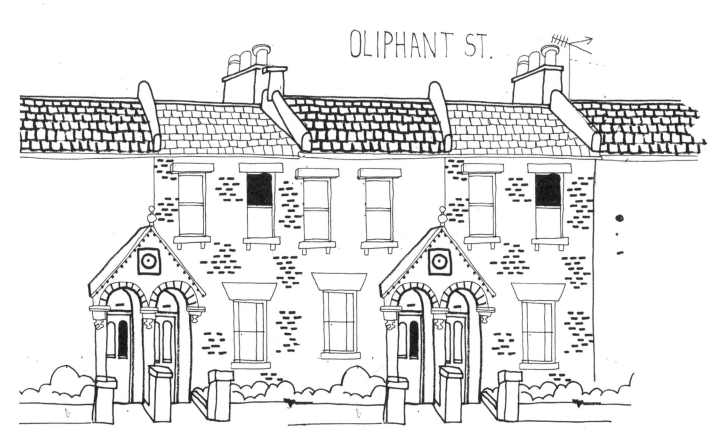

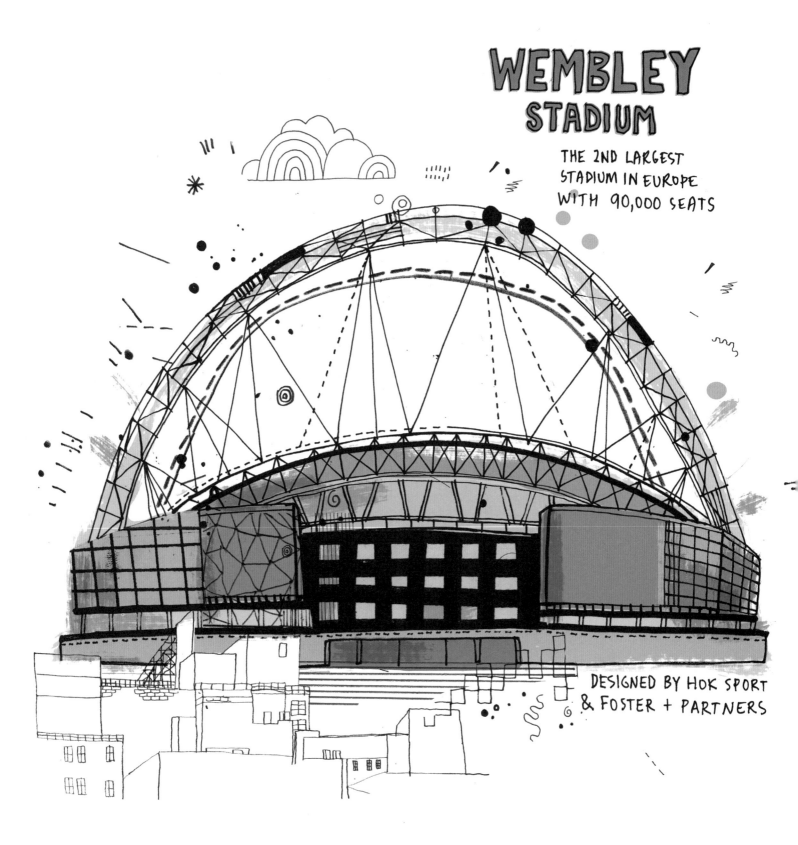

WEMBLEY STADIUM

THE 2ND LARGEST STADIUM IN EUROPE WITH 90,000 SEATS

DESIGNED BY HOK SPORT & FOSTER + PARTNERS

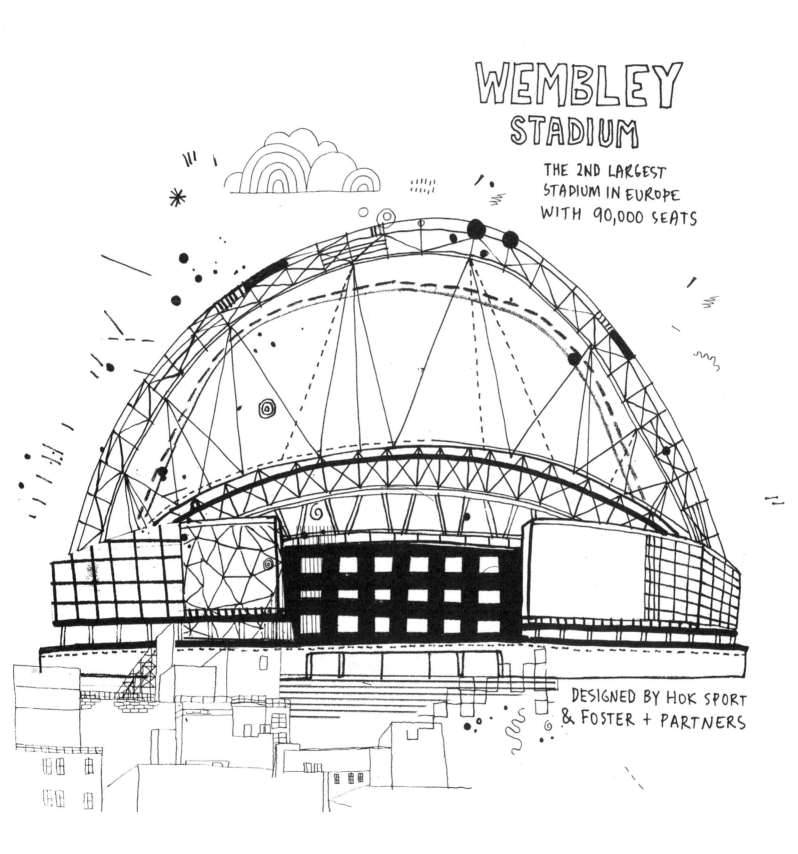

WEMBLEY
STADIUM

THE 2ND LARGEST
STADIUM IN EUROPE
WITH 90,000 SEATS

DESIGNED BY HOK SPORT
& FOSTER + PARTNERS

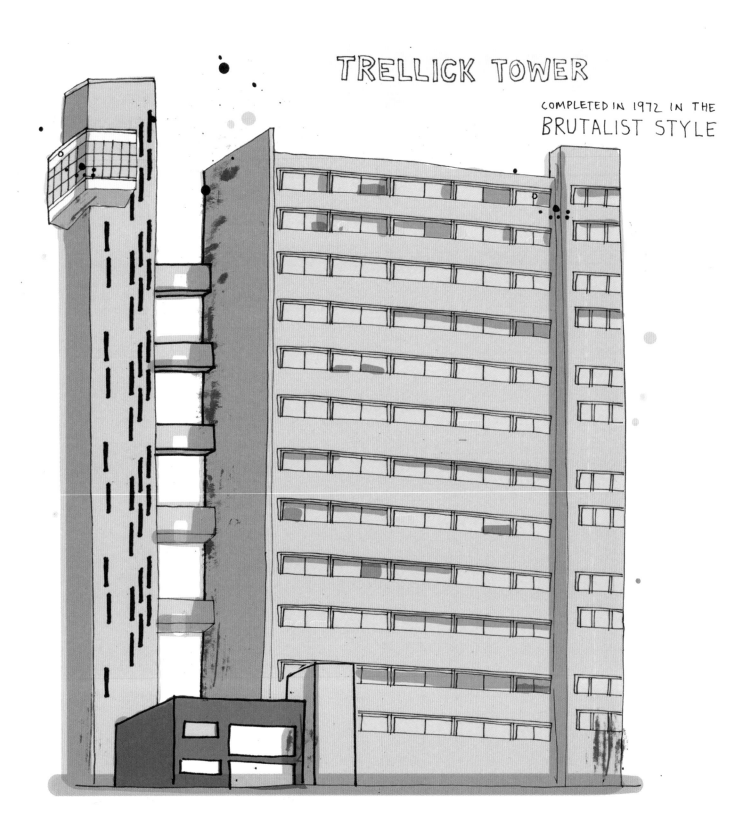

TRELLICK TOWER

COMPLETED IN 1972 IN THE
BRUTALIST STYLE

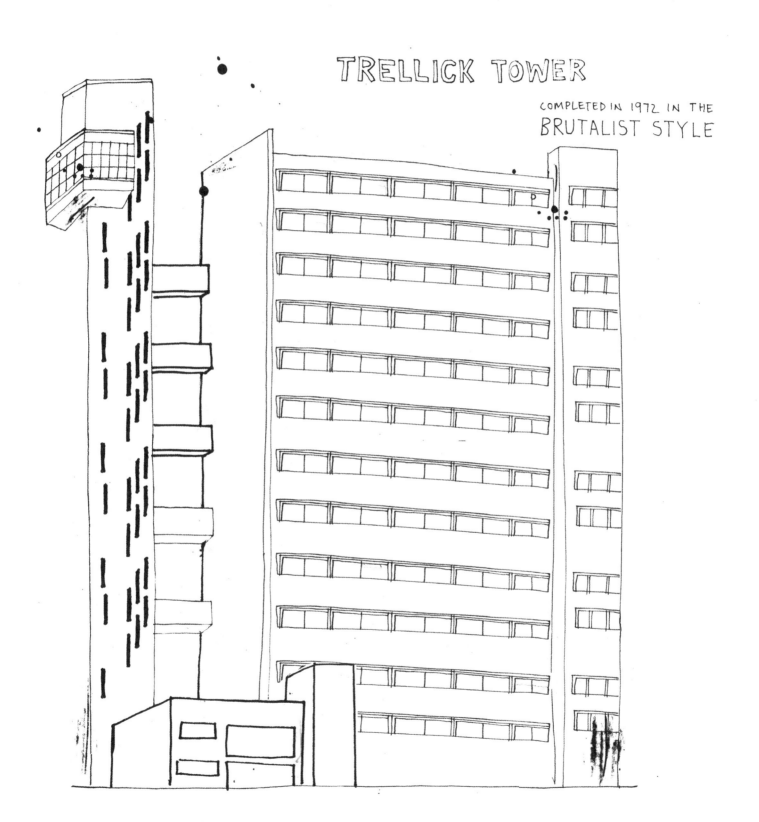

TRELLICK TOWER

COMPLETED IN 1972 IN THE
BRUTALIST STYLE

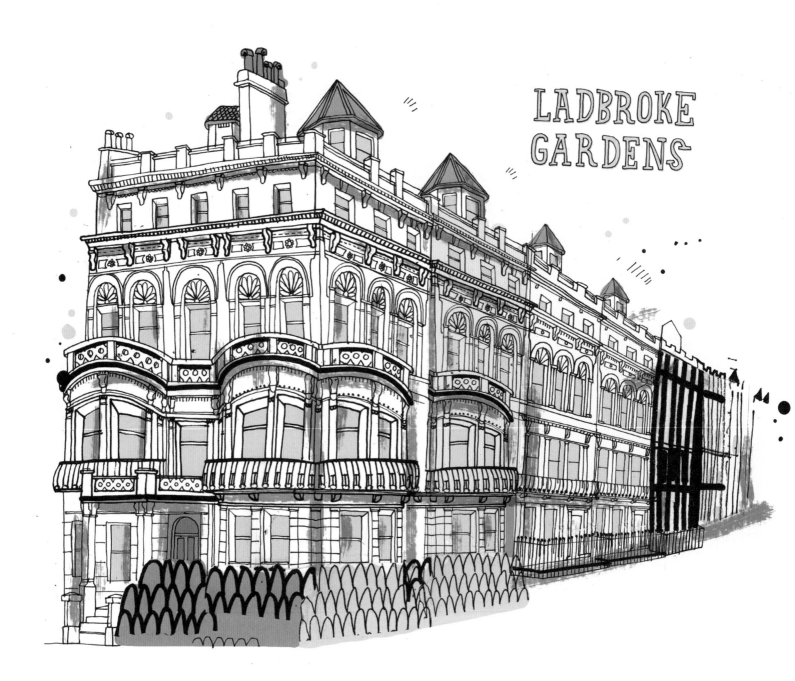

LADBROKE GARDENS

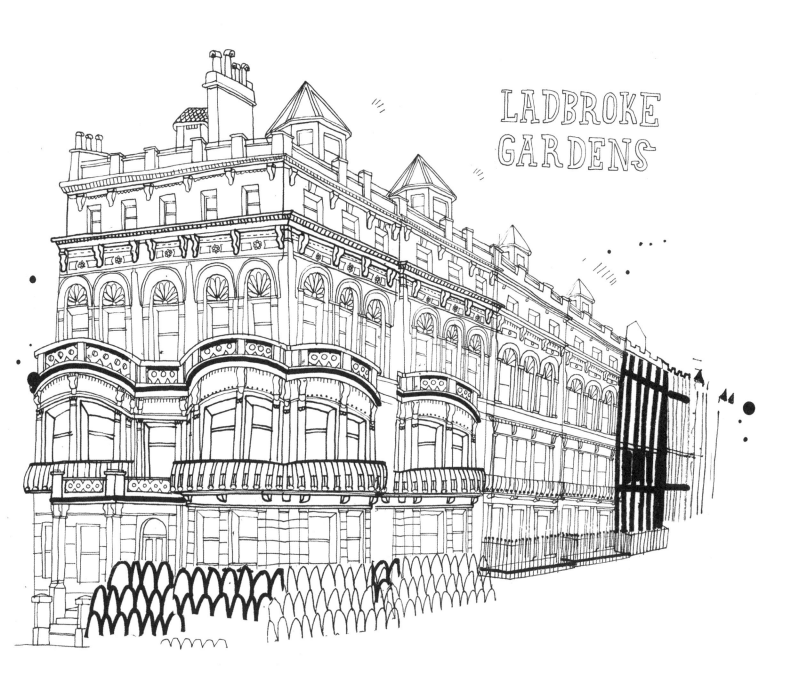

LADBROKE GARDENS

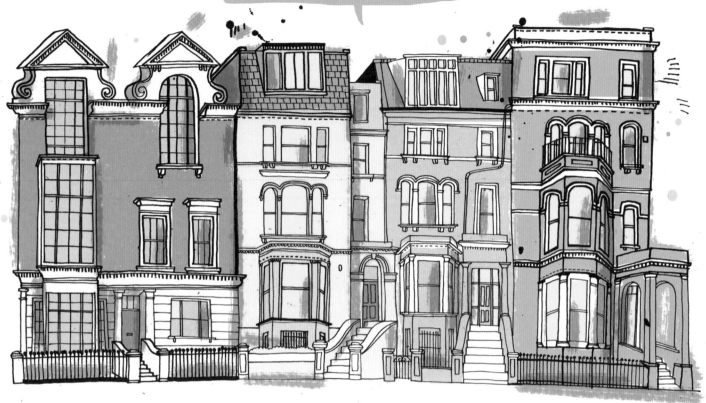

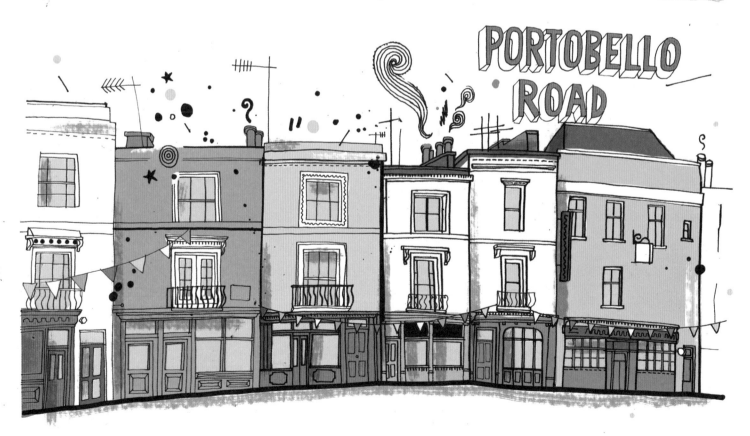

45-49A BLENHEIM CRESCENT

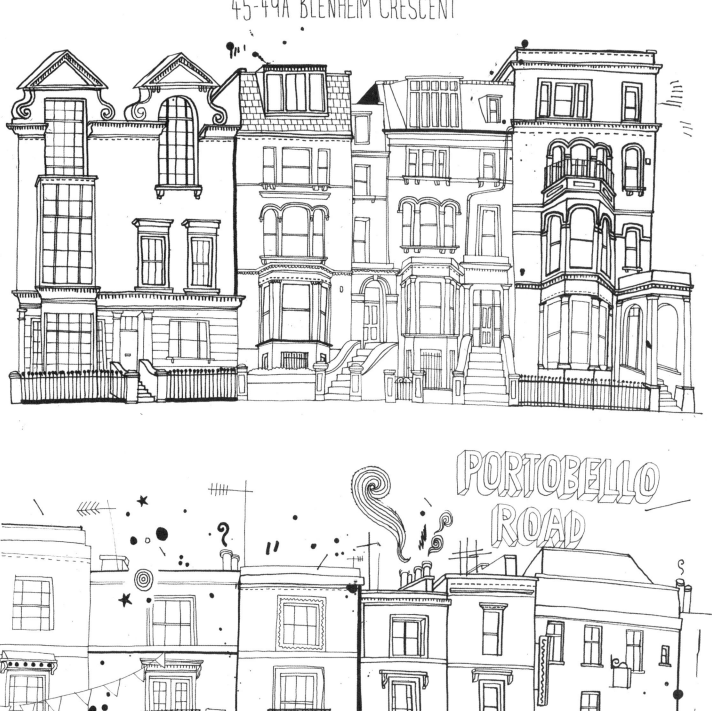

PORTOBELLO ROAD

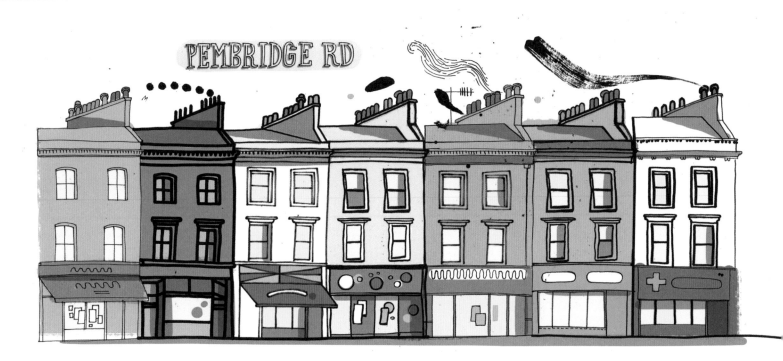

PEMBRIDGE RD

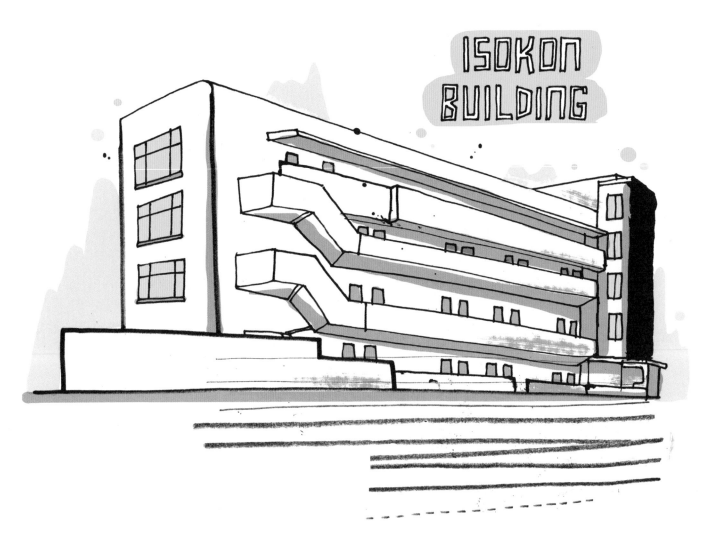

ISOKON BUILDING

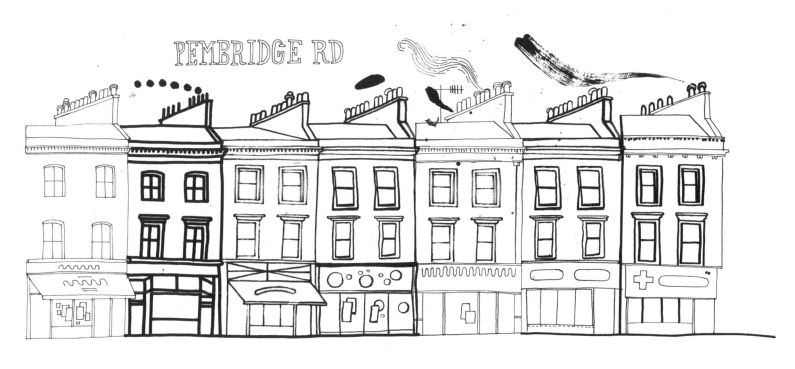

PEMBRIDGE RD

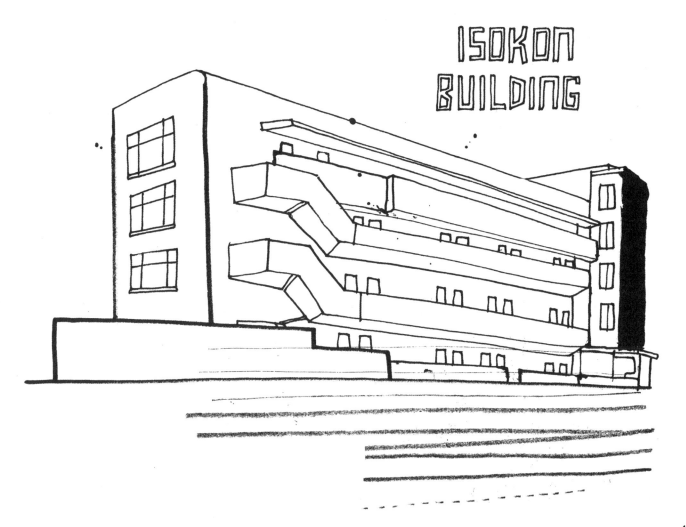

ISOKON BUILDING

24 LEINSTER GARDENS

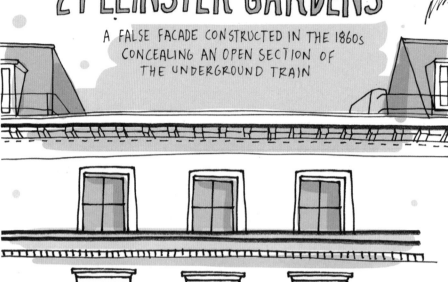

A FALSE FACADE CONSTRUCTED IN THE 1860s CONCEALING AN OPEN SECTION OF THE UNDERGROUND TRAIN

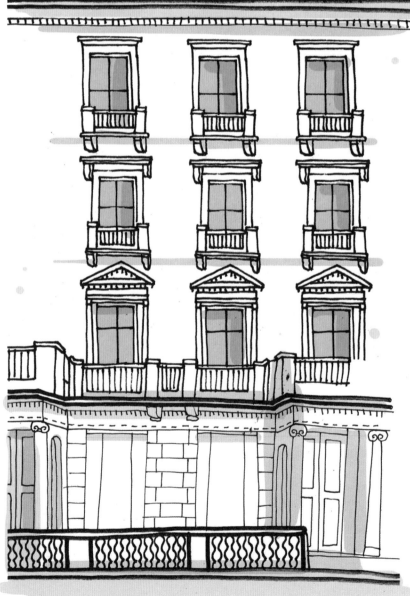

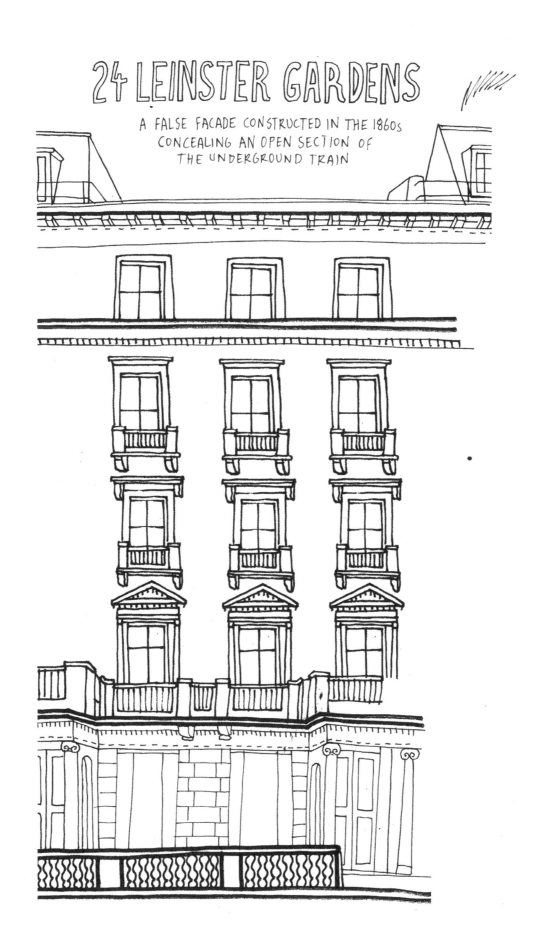

24 LEINSTER GARDENS

A FALSE FACADE CONSTRUCTED IN THE 1860s
CONCEALING AN OPEN SECTION OF
THE UNDERGROUND TRAIN

MARBLE ARCH

SMALL ROOMS INSIDE THE ARCH WERE USED AS A POLICE STATION

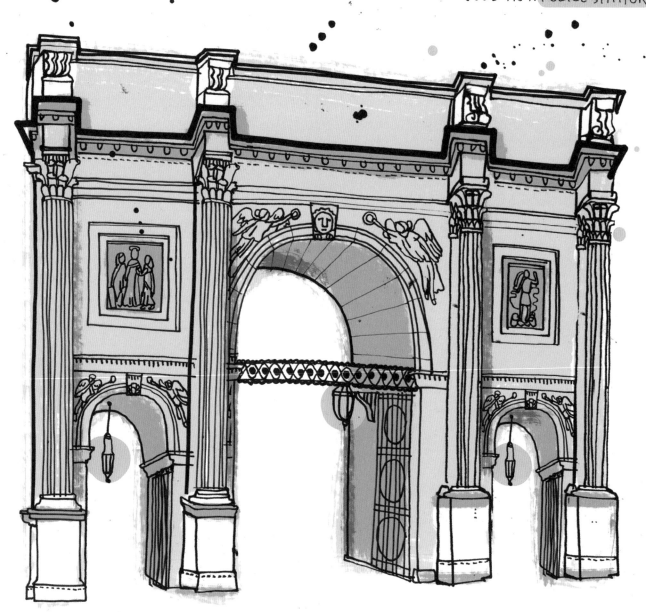

DESIGNED BY JOHN NASH AS A CEREMONIAL ENTRANCE TO BUCKINGHAM PALACE IN 1827.

IT WAS MOVED TO ITS CURRENT LOCATION IN 1851

MARBLE ARCH

SMALL ROOMS
INSIDE THE ARCH WERE
USED AS A POLICE STATION

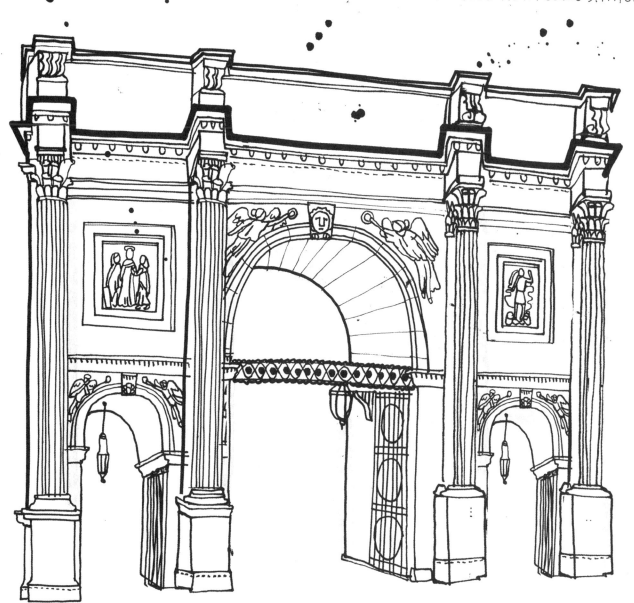

DESIGNED BY JOHN NASH
AS A CEREMONIAL ENTRANCE
TO BUCKINGHAM PALACE IN 1827.

IT WAS MOVED TO ITS CURRENT
LOCATION IN 1851

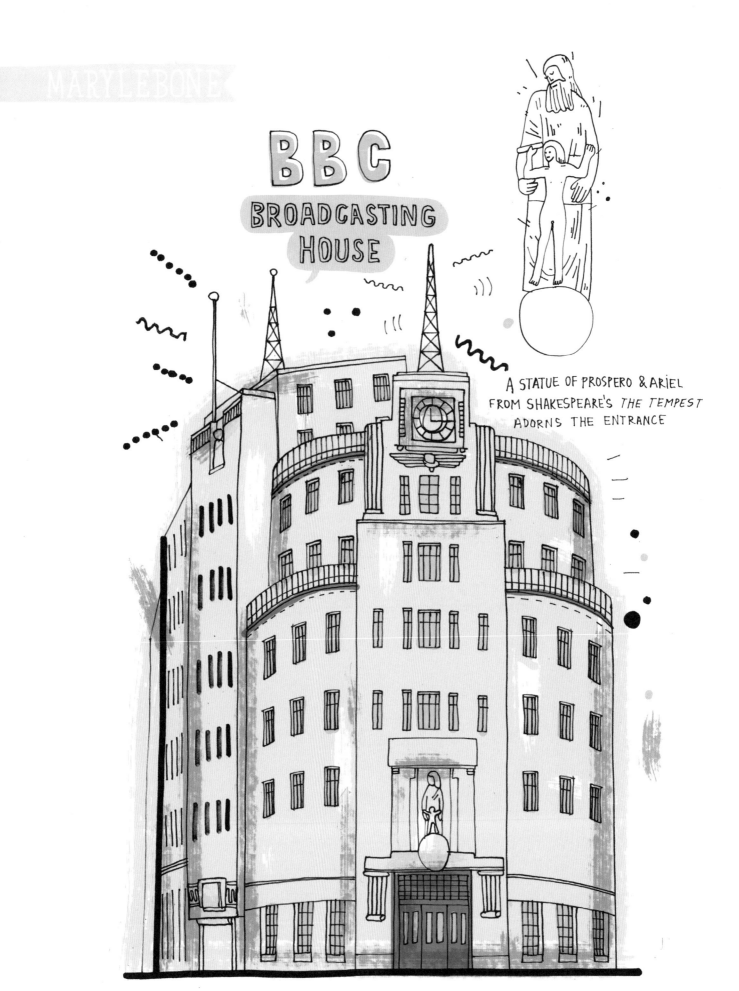

BBC

BROADCASTING HOUSE

A STATUE OF PROSPERO & ARIEL FROM SHAKESPEARE'S *THE TEMPEST* ADORNS THE ENTRANCE

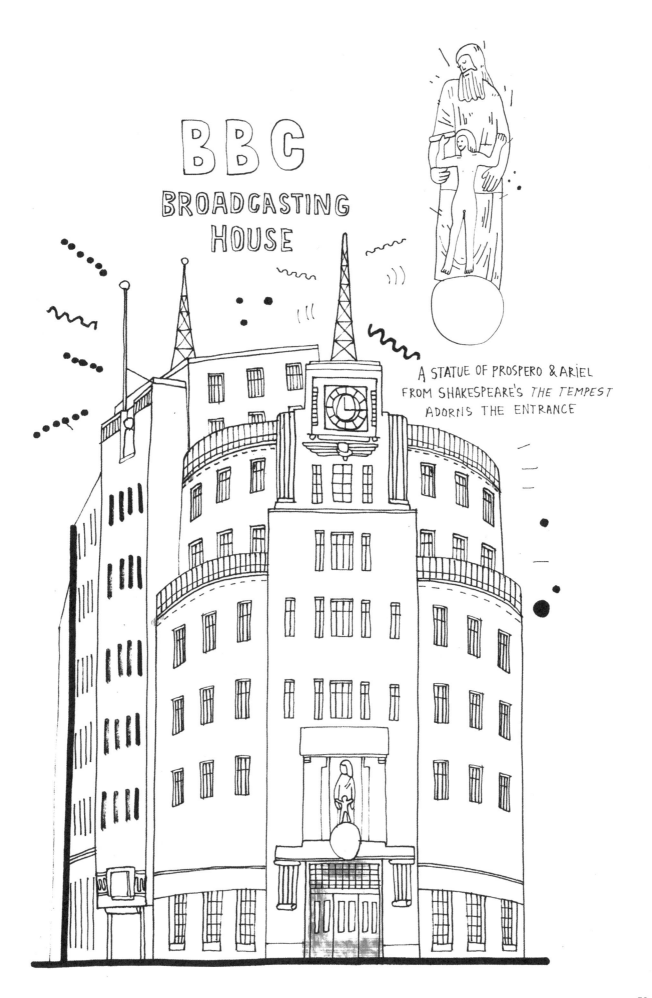

BBC
BROADCASTING
HOUSE

A STATUE OF PROSPERO & ARIEL
FROM SHAKESPEARE'S *THE TEMPEST*
ADORNS THE ENTRANCE

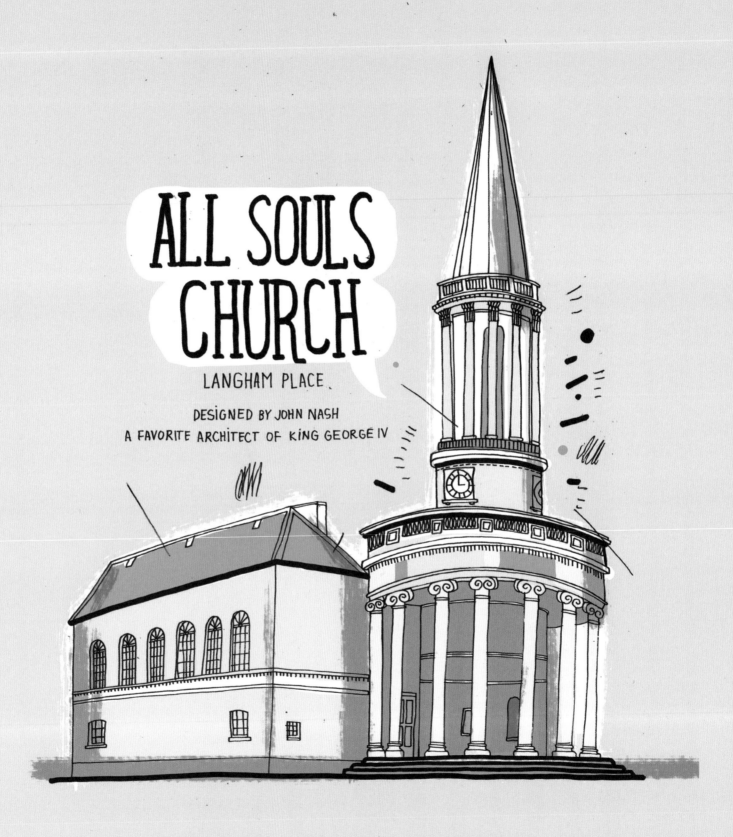

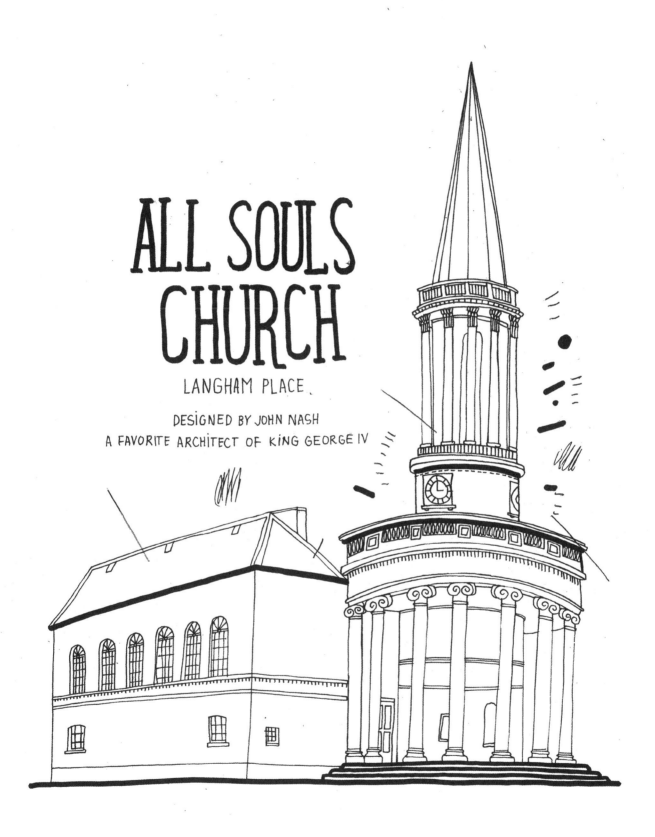

ALL SOULS CHURCH

LANGHAM PLACE.

DESIGNED BY JOHN NASH
A FAVORITE ARCHITECT OF KING GEORGE IV

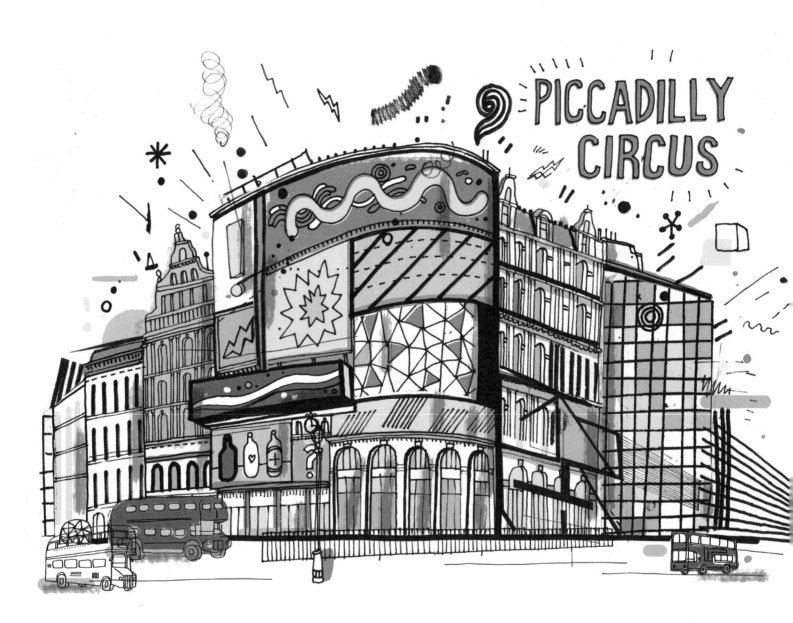

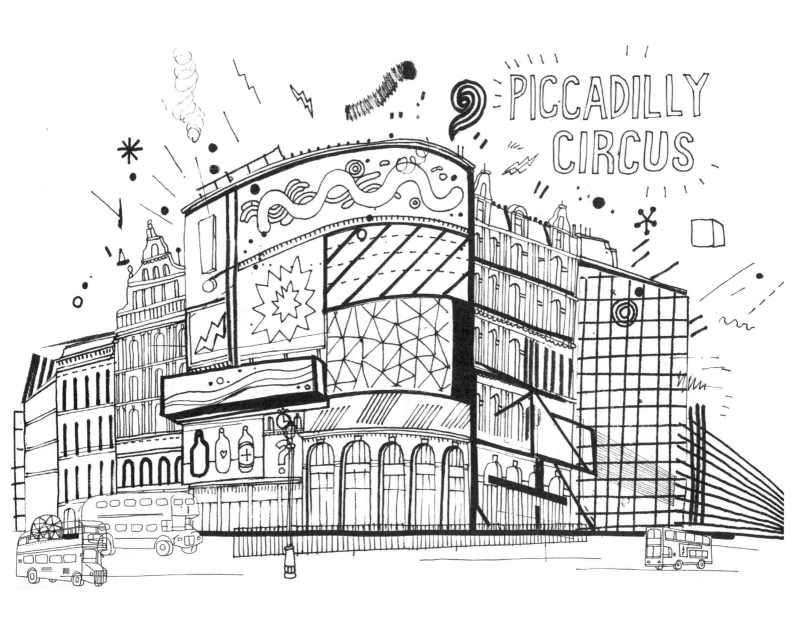

PICCADILLY CIRCUS

BURLINGTON ARCADE

HAS THE OLDEST & SMALLEST POLICE FORCE IN THE WORLD, THE BURLINGTON BEADLES. THEY UPHOLD A STRICT CODE OF CONDUCT INCLUDING NO WHISTLING!

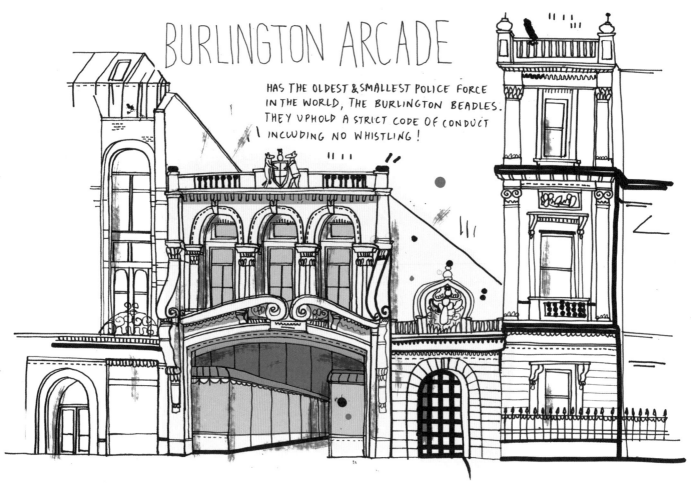

HATCHARDS
187 PICCADILLY

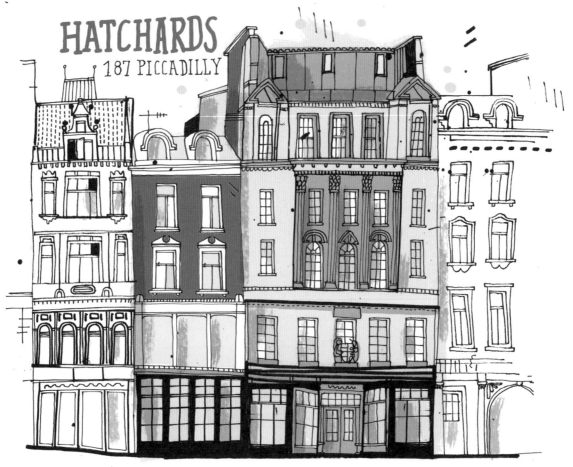

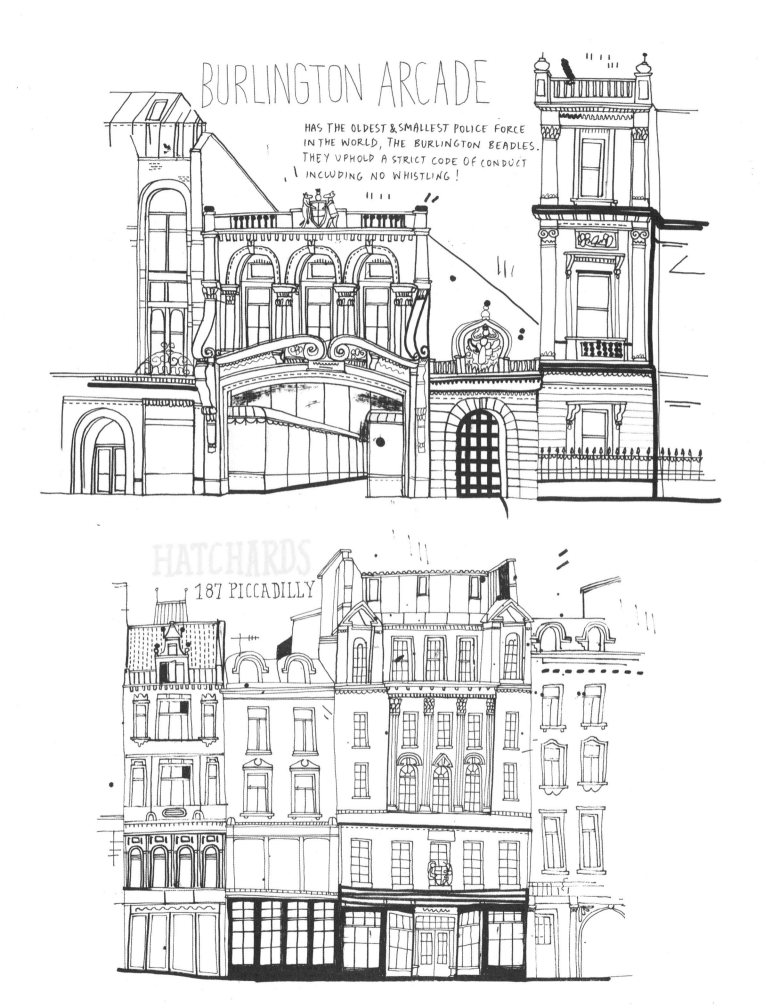

BURLINGTON ARCADE

HAS THE OLDEST & SMALLEST POLICE FORCE IN THE WORLD, THE BURLINGTON BEADLES. THEY UPHOLD A STRICT CODE OF CONDUCT INCLUDING NO WHISTLING!

HATCHARDS
187 PICCADILLY

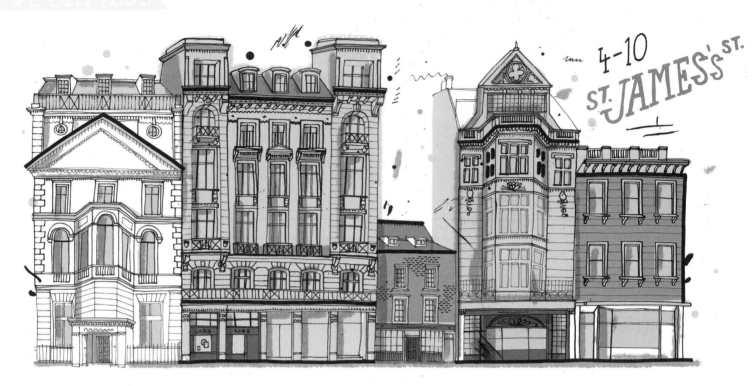

4-10
ST. JAMES'S ST.

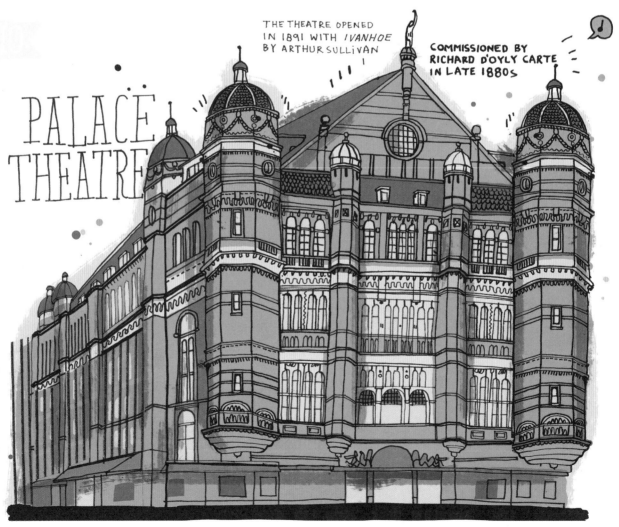

THE THEATRE OPENED
IN 1891 WITH *IVANHOE*
BY ARTHUR SULLIVAN

COMMISSIONED BY
RICHARD D'OYLY CARTE
IN LATE 1880s

PALACE
THEATRE

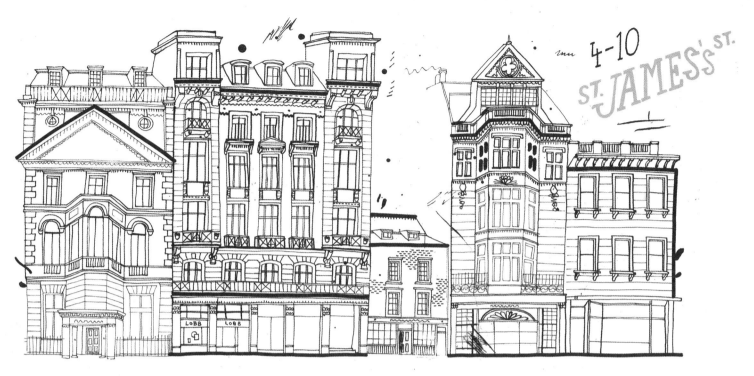

4-10
ST. JAMES'S ST.

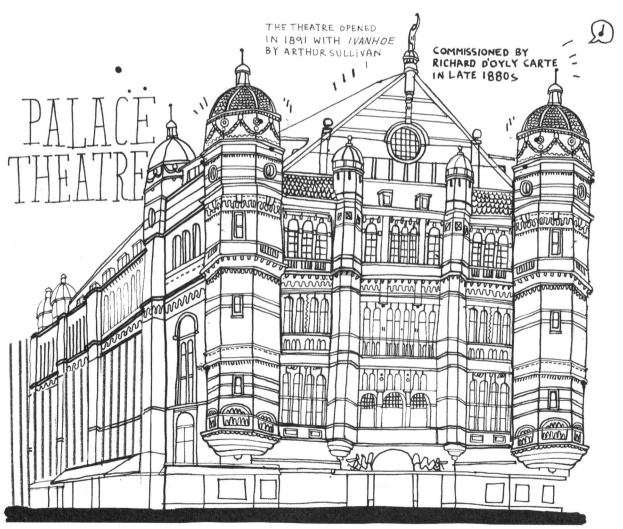

THE THEATRE OPENED
IN 1891 WITH *IVANHOE*
BY ARTHUR SULLIVAN

COMMISSIONED BY
RICHARD D'OYLY CARTE
IN LATE 1880s

PALACE
THEATRE

LIBERTY
REGENT ST.

IN 1924 THE TUDOR REVIVAL
BUILDING WAS CONSTRUCTED
FROM THE TIMBER OF TWO SHIPS:
THE HMS IMPREGNABLE
& HMS HINDUSTAN

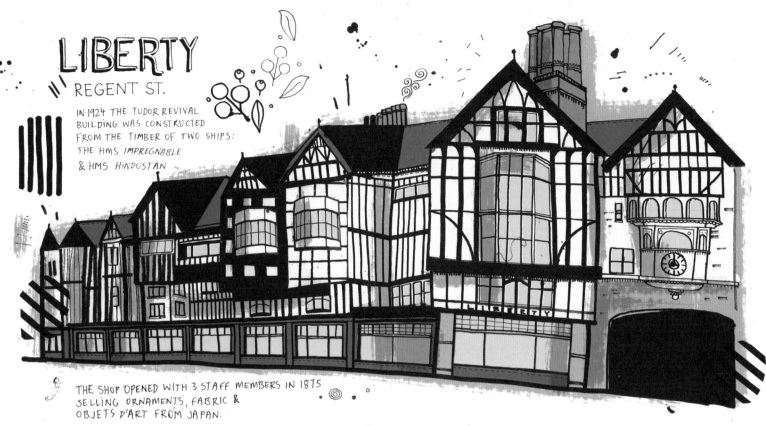

THE SHOP OPENED WITH 3 STAFF MEMBERS IN 1875
SELLING ORNAMENTS, FABRIC &
OBJETS D'ART FROM JAPAN.

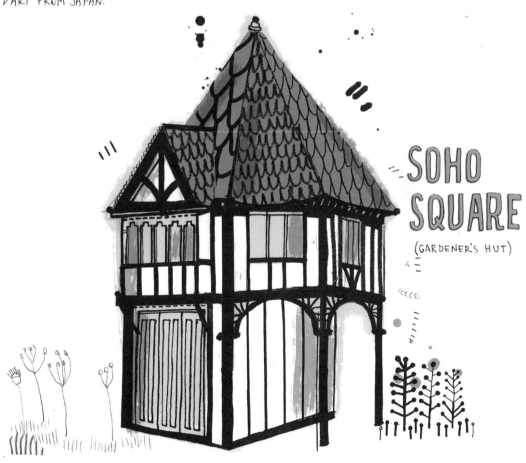

SOHO
SQUARE
(GARDENER'S HUT)

LIBERTY
REGENT ST.

IN 1924 THE TUDOR REVIVAL
BUILDING WAS CONSTRUCTED
FROM THE TIMBER OF TWO SHIPS:
THE HMS IMPREGNABLE
& HMS HINDUSTAN

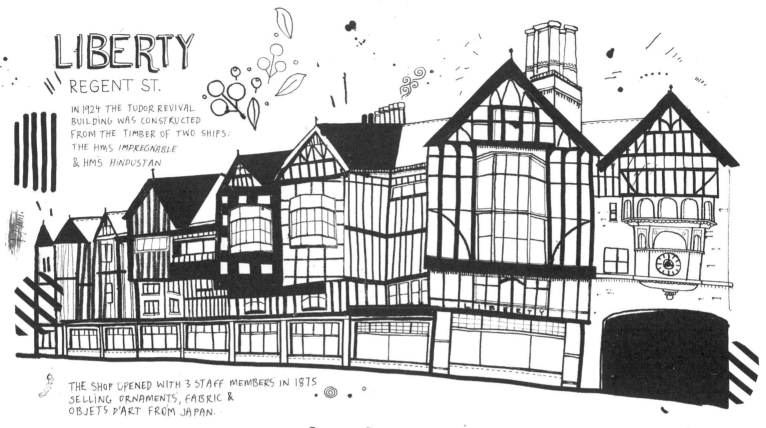

THE SHOP OPENED WITH 3 STAFF MEMBERS IN 1875
SELLING ORNAMENTS, FABRIC &
OBJETS D'ART FROM JAPAN.

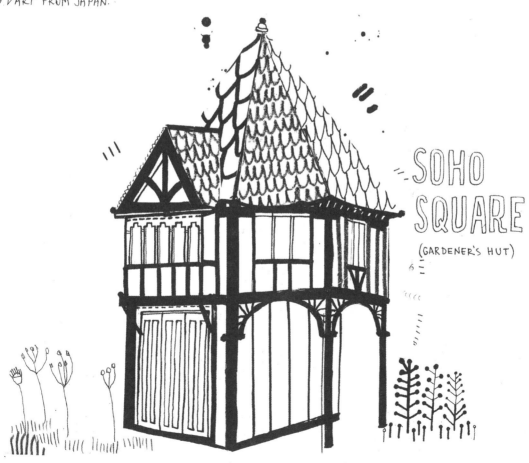

SOHO
SQUARE
(GARDENER'S HUT)

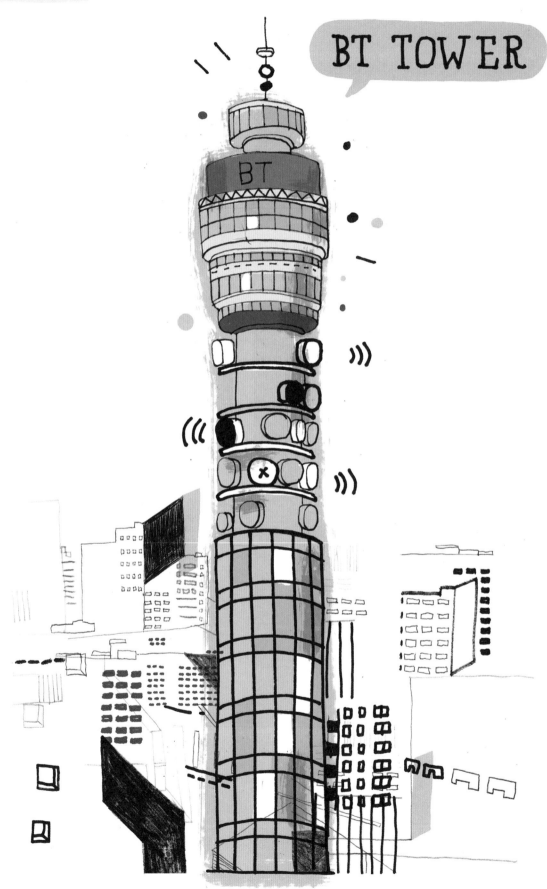

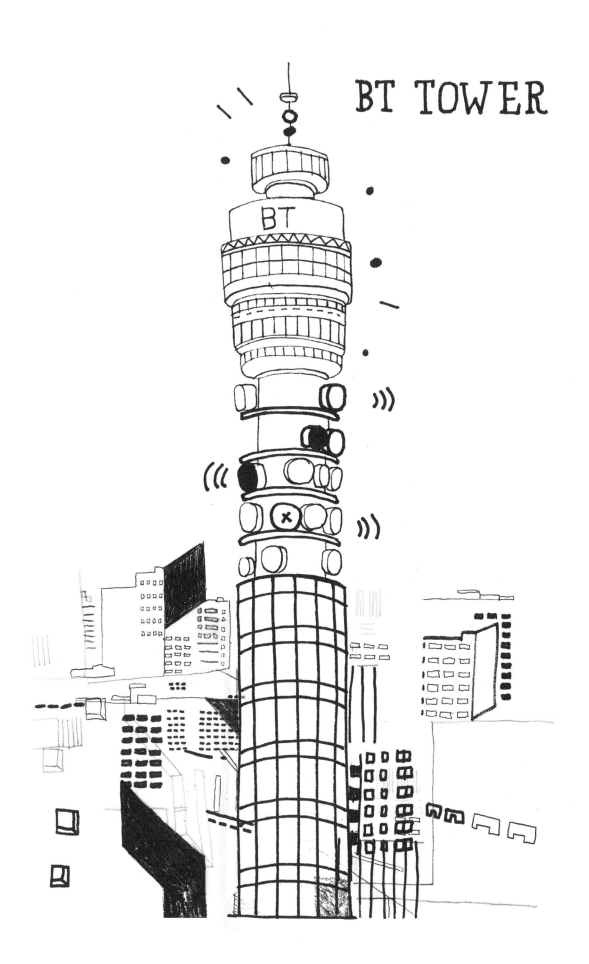

BT TOWER

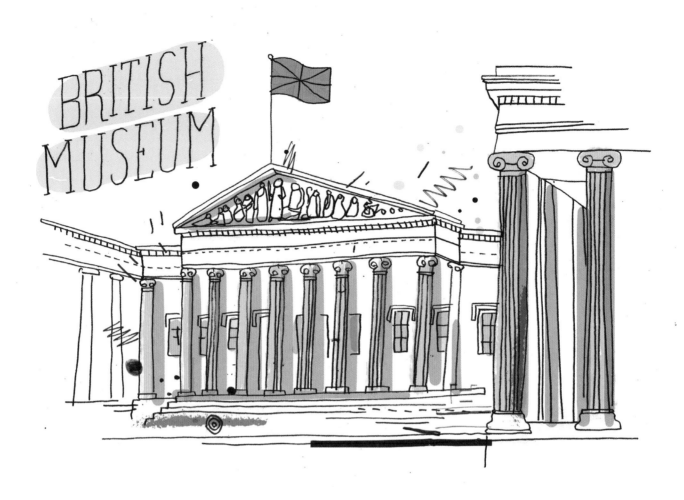

BRITISH MUSEUM

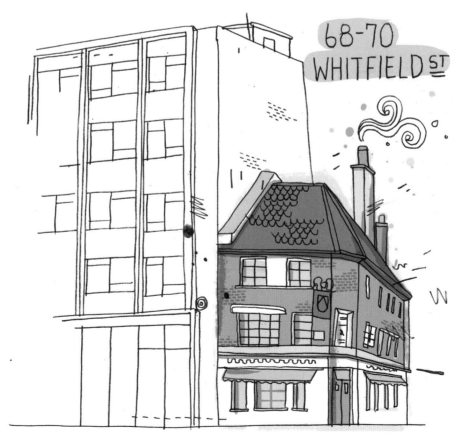

68-70 WHITFIELD ST

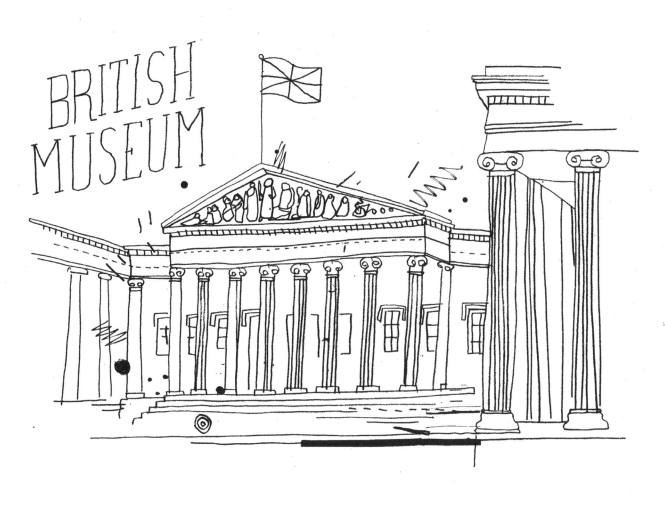

BRITISH MUSEUM

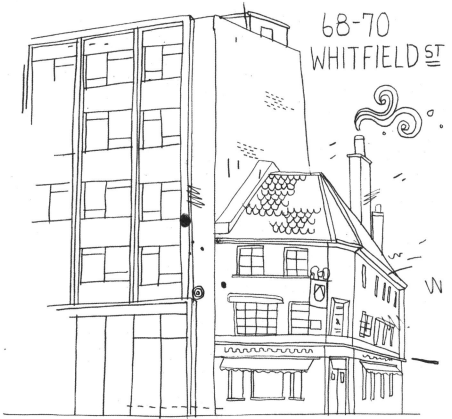

68-70 WHITFIELD ST

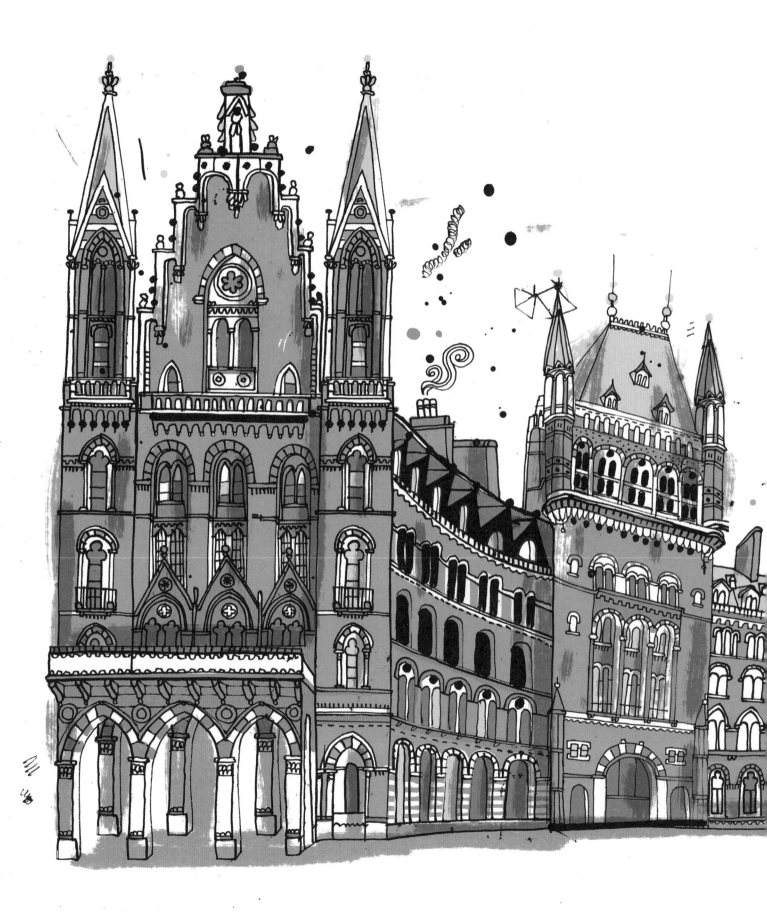

THE LONDON UNDEGROUND
AND EUROSTAR TO FRANCE
STOP HERE.

ST PANCRAS STATION

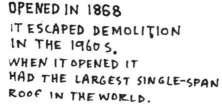

OPENED IN 1868
IT ESCAPED DEMOLITION
IN THE 1960s.
WHEN IT OPENED IT
HAD THE LARGEST SINGLE-SPAN
ROOF IN THE WORLD.

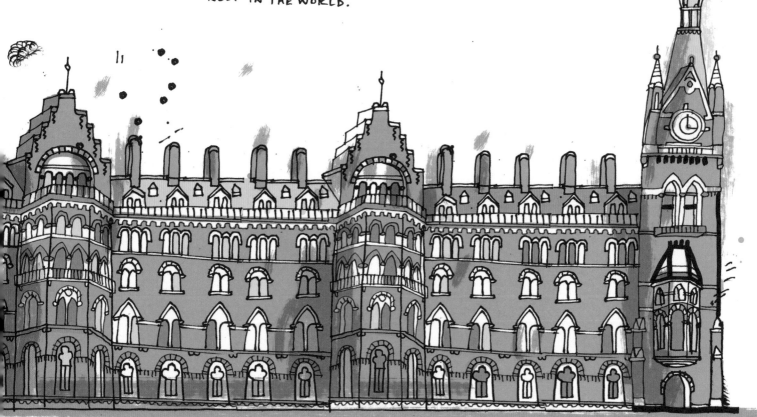

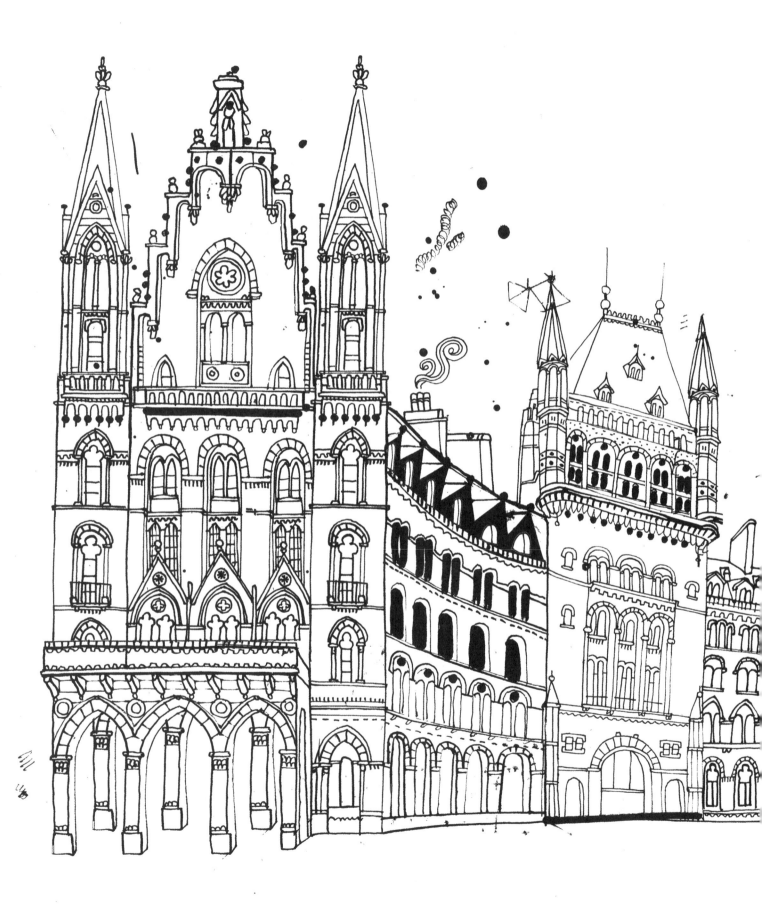

THE LONDON UNDEGROUND
AND EUROSTAR TO FRANCE
STOP HERE.

ST PANCRAS STATION

OPENED IN 1868
IT ESCAPED DEMOLITION
IN THE 1960S.
WHEN IT OPENED IT
HAD THE LARGEST SINGLE-SPAN
ROOF IN THE WORLD.

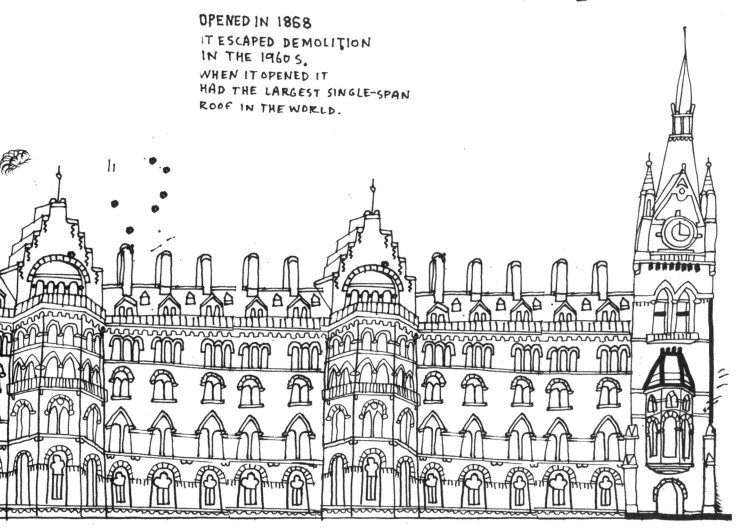

SOANE
MUSEUM

13 LINCOLN'S INN FIELDS

HOLDS THE COLLECTION OF JOHN SOANE'S ANTIQUITIES INCLUDING THE ALABASTER SARCOPHAGUS OF SETi 1 BOUGHT IN 1824 FOR £2000.

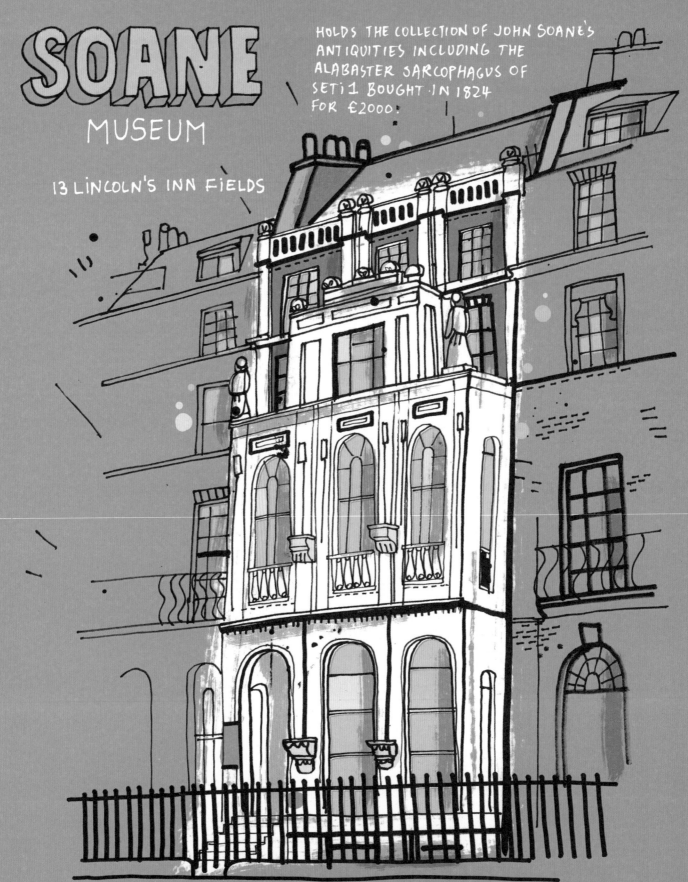

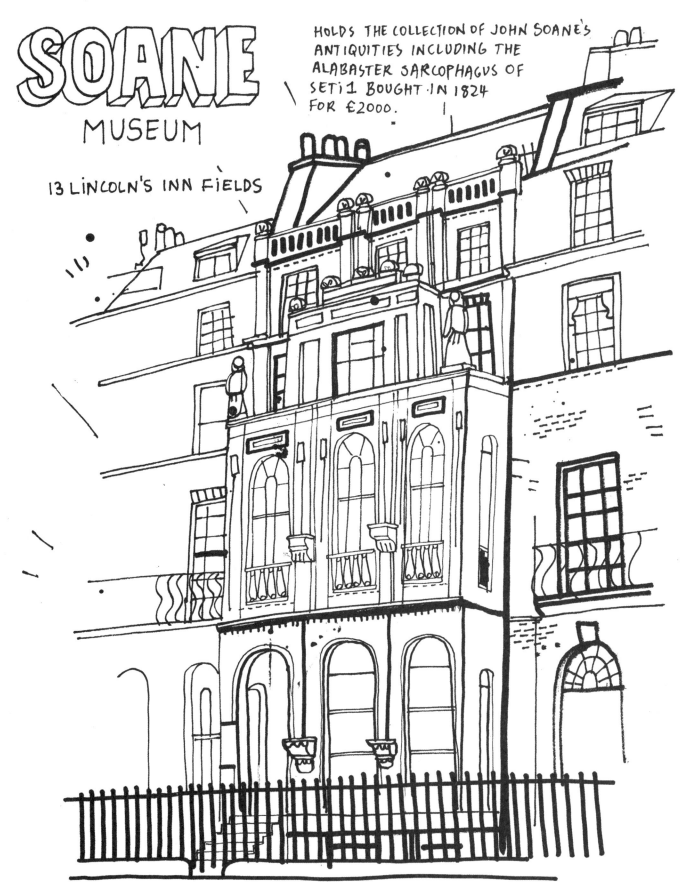

SOANE
MUSEUM

HOLDS THE COLLECTION OF JOHN SOANE'S ANTIQUITIES INCLUDING THE ALABASTER SARCOPHAGUS OF SETi 1 BOUGHT IN 1824 FOR £2000.

13 LINCOLN'S INN FIELDS

138-142 HOLBORN

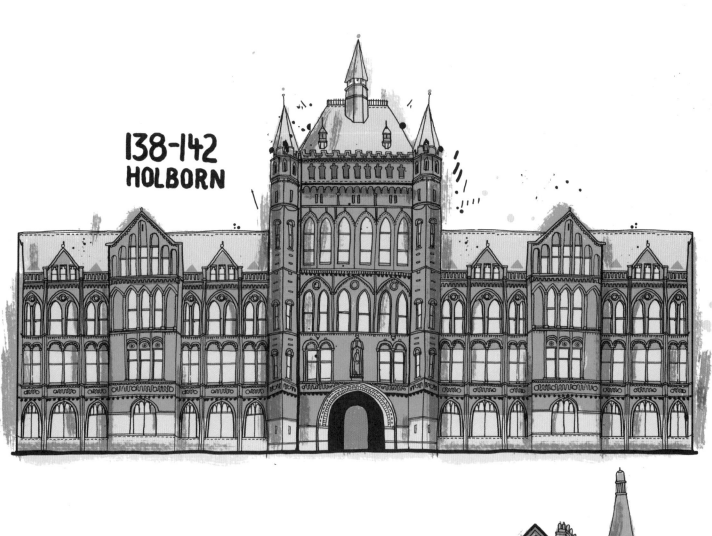

STAPLE INN BUILDING

HIGH HOLBORN ST.

ONCE WOOL WAS WEIGHED + TAXED HERE

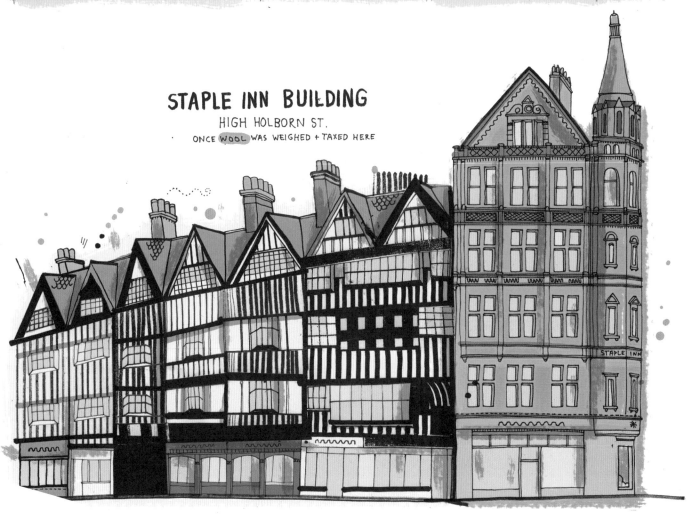

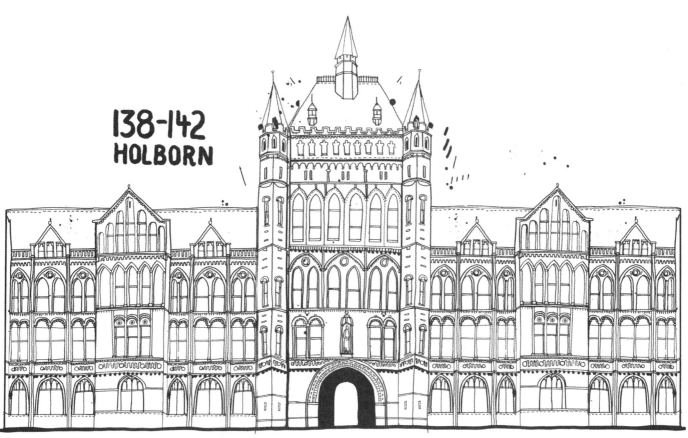

138-142
HOLBORN

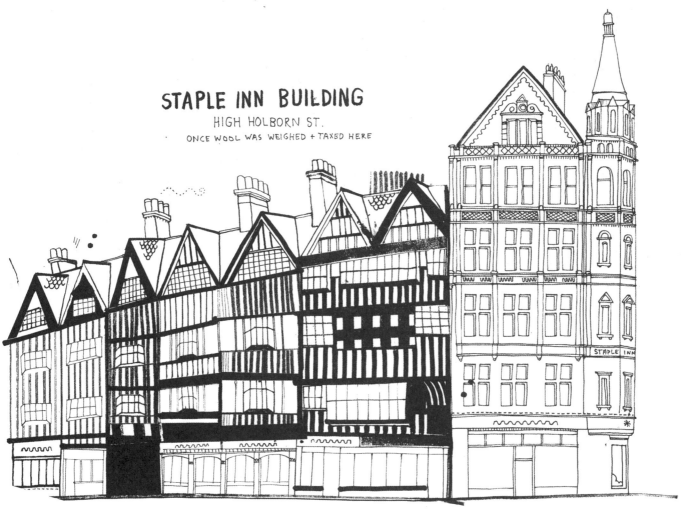

STAPLE INN BUILDING
HIGH HOLBORN ST.
ONCE WOOL WAS WEIGHED + TAXED HERE

STAPLE INN

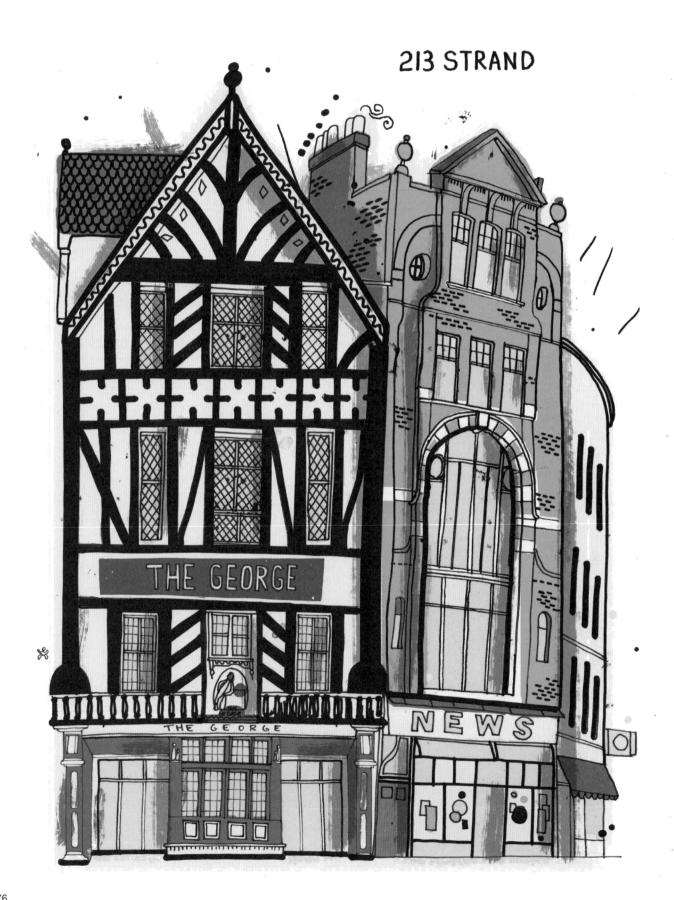

213 STRAND

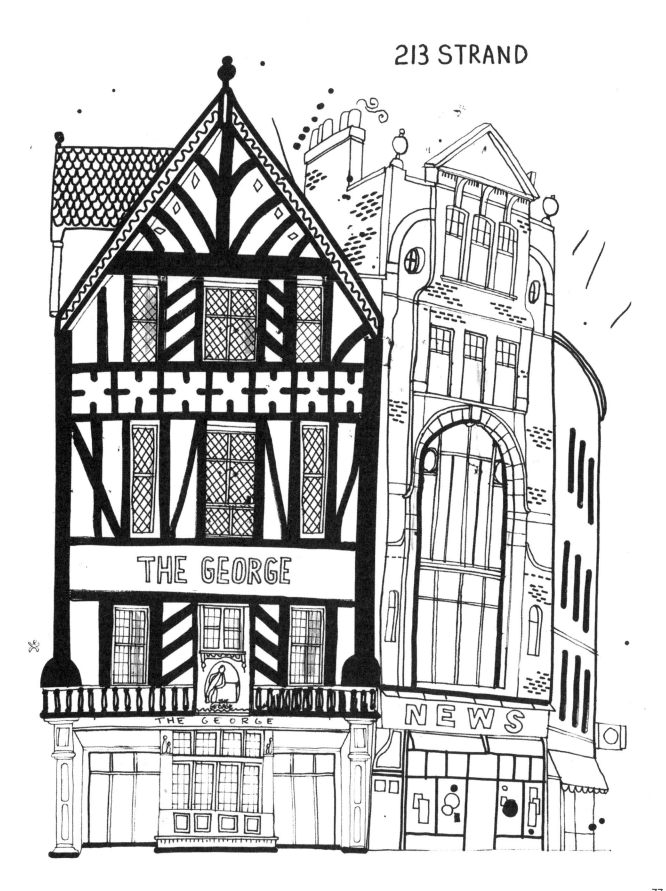

213 STRAND

THE GEORGE

THE GEORGE

NEWS

117-119 CLERKENWELL RD.

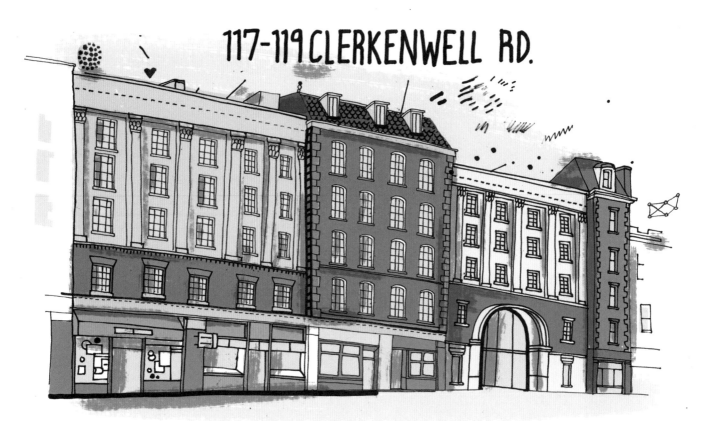

FARMILOE BUILDING

34 ST JOHN ST.

USED AS THE GOTHAM CITY POLICE HEADQUARTERS IN BATMAN BEGINS AND THE DARK KNIGHT

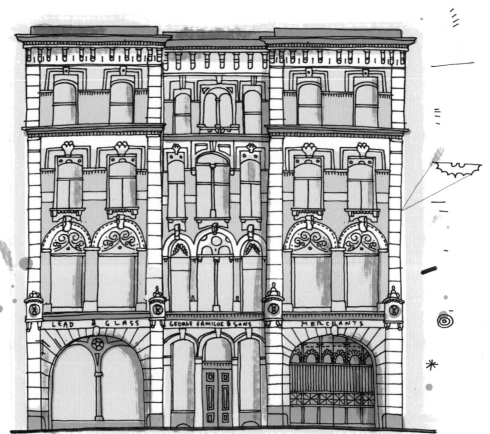

117-119 CLERKENWELL RD.

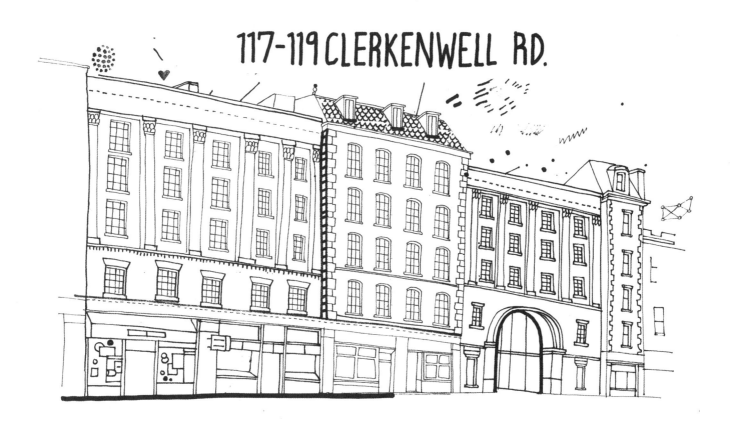

FARMILOE
BUILDING
34 ST JOHN ST.

USED AS THE GOTHAM CITY
POLICE HEADQUARTERS IN
BATMAN BEGINS AND
THE DARK KNIGHT

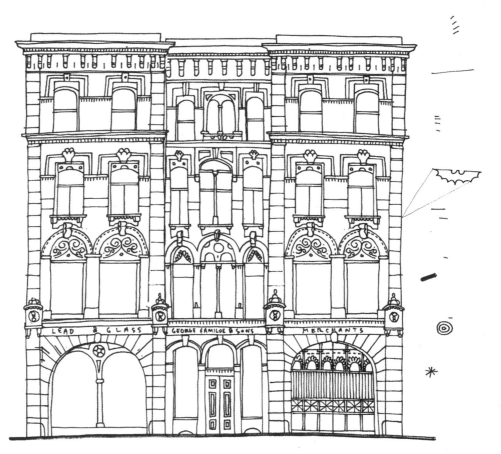

LEAD & GLASS GEORGE FARMILOE & SONS MERCHANTS

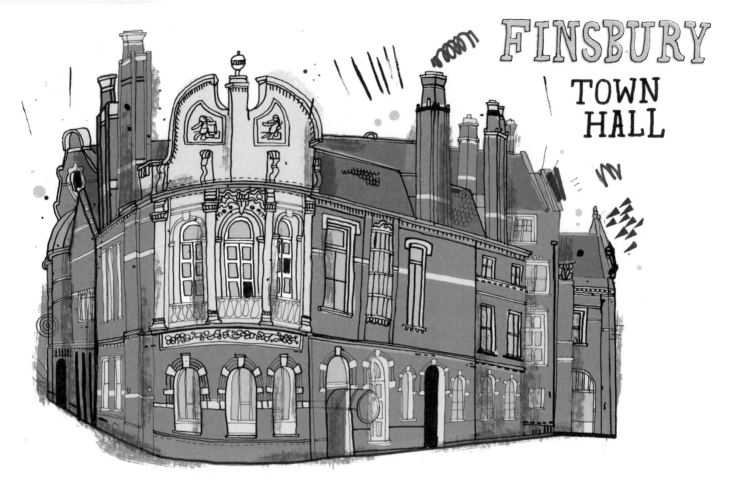

FINSBURY
TOWN HALL

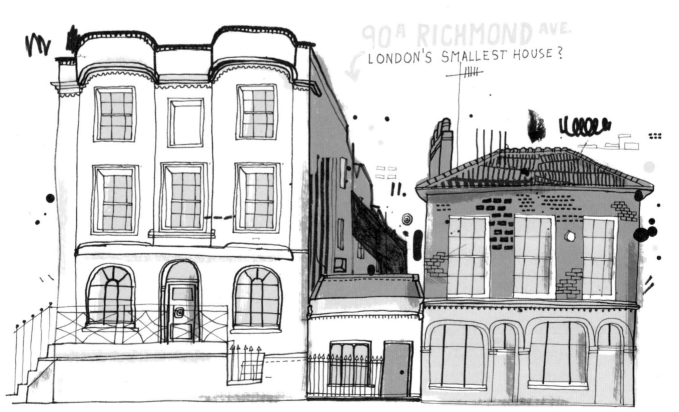

90ᴬ RICHMOND AVE.
LONDON'S SMALLEST HOUSE?

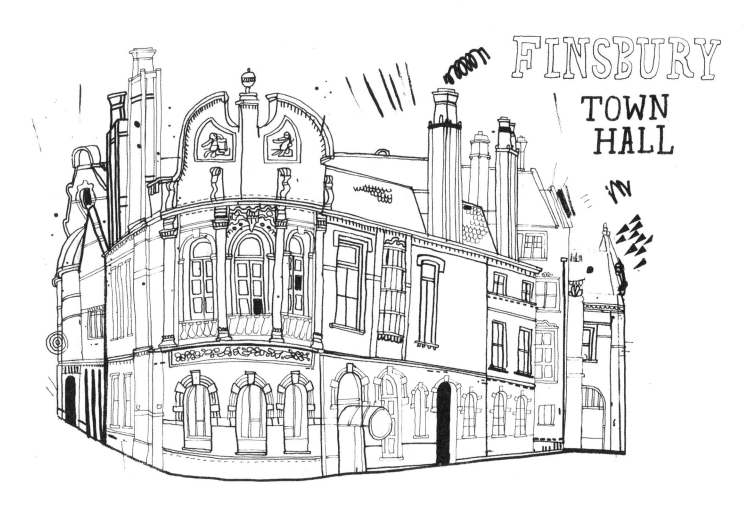

FINSBURY
TOWN HALL

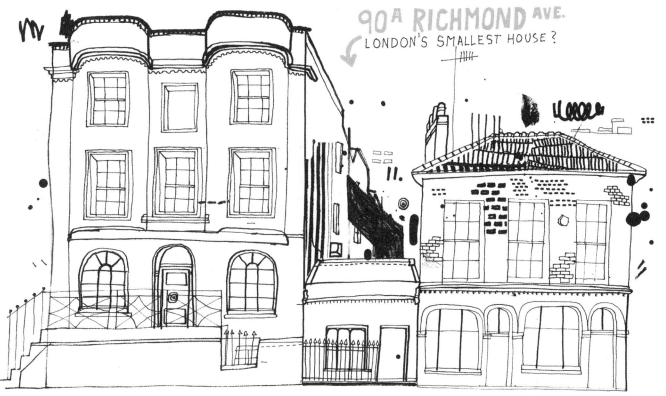

90ᴬ RICHMOND AVE.
LONDON'S SMALLEST HOUSE?

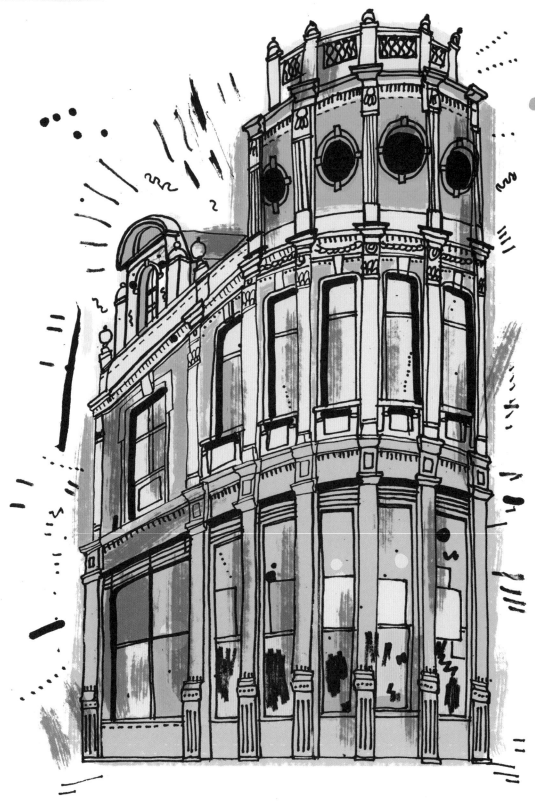

GENERAL MARKET BUILDING

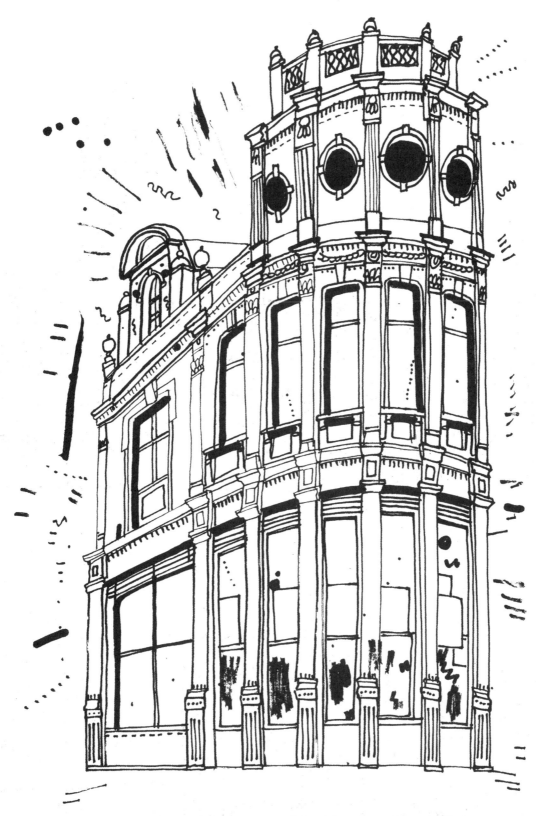

GENERAL MARKET BUILDING

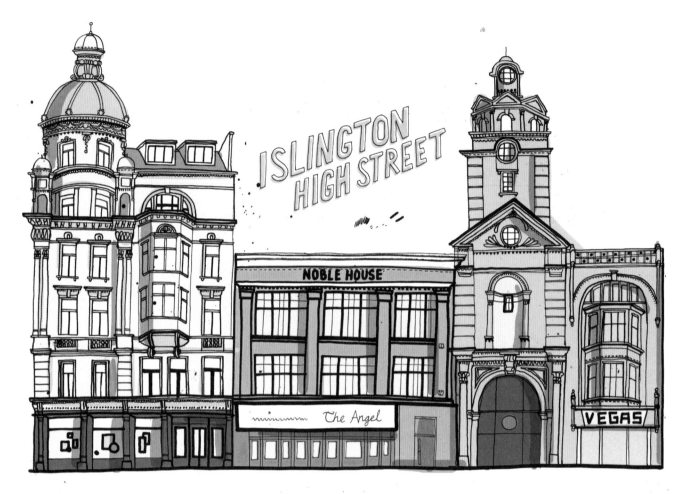

ISLINGTON HIGH STREET

NOBLE HOUSE

The Angel

VEGAS

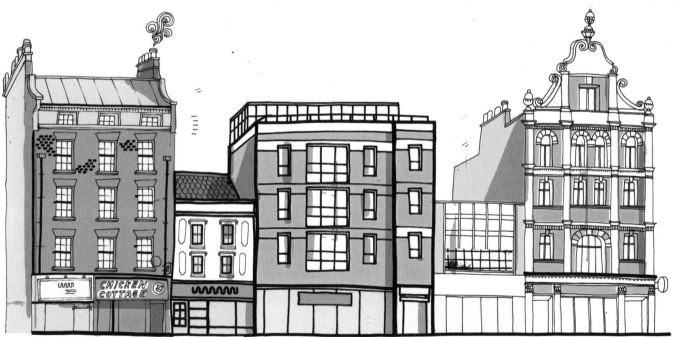

CHICKEN COTTAGE

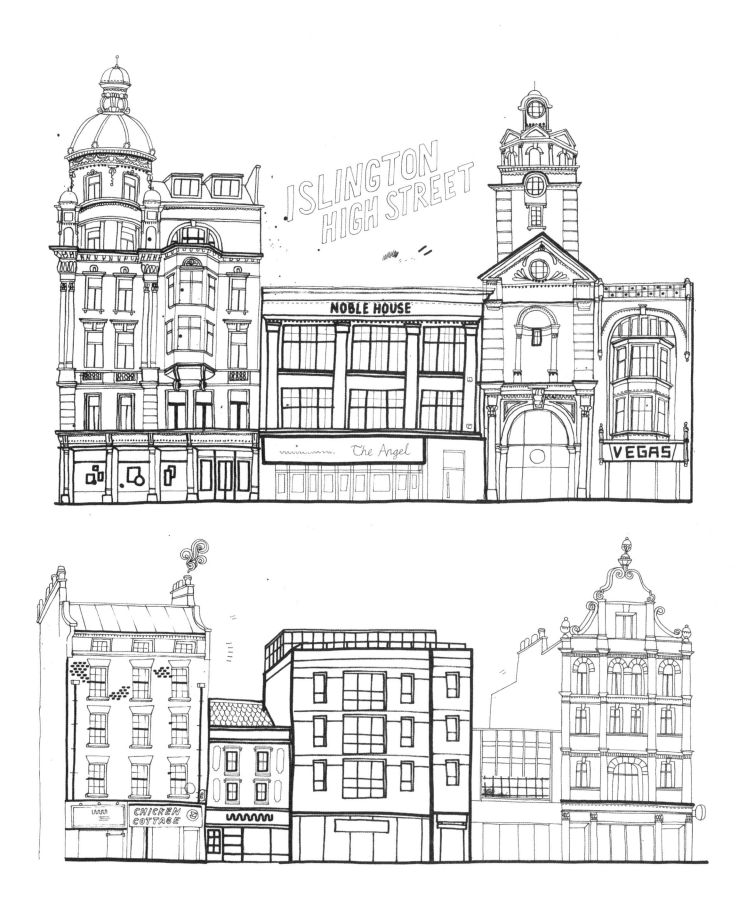

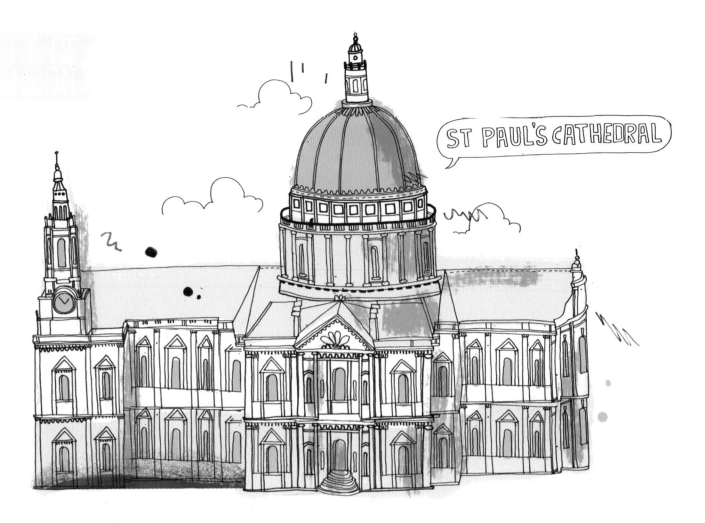

ST PAUL'S CATHEDRAL

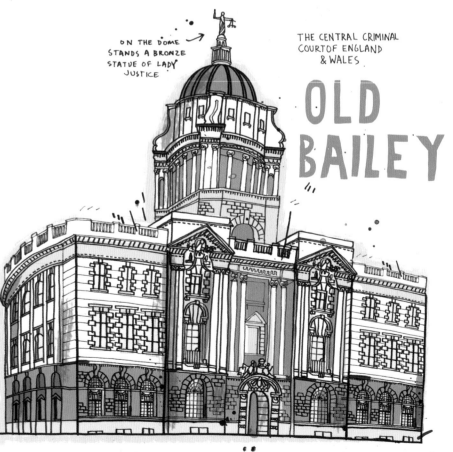

ON THE DOME STANDS A BRONZE STATUE OF LADY JUSTICE

THE CENTRAL CRIMINAL COURT OF ENGLAND & WALES

OLD BAILEY

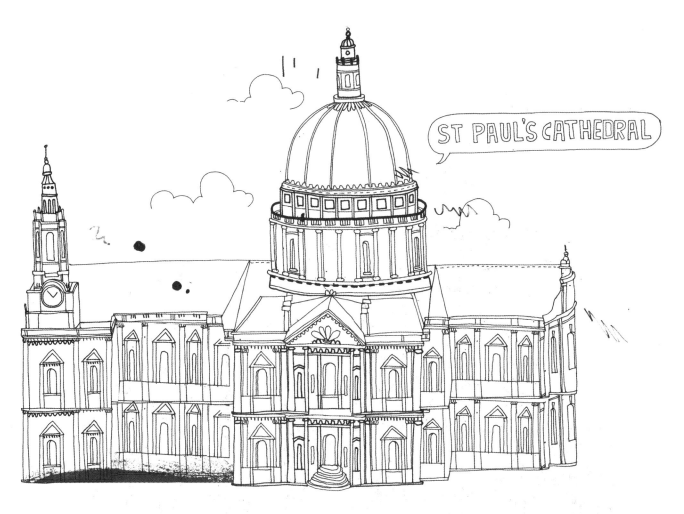

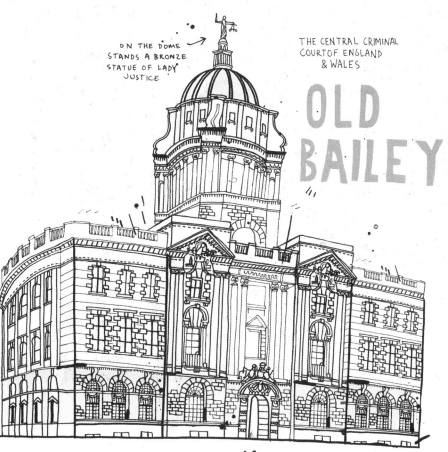

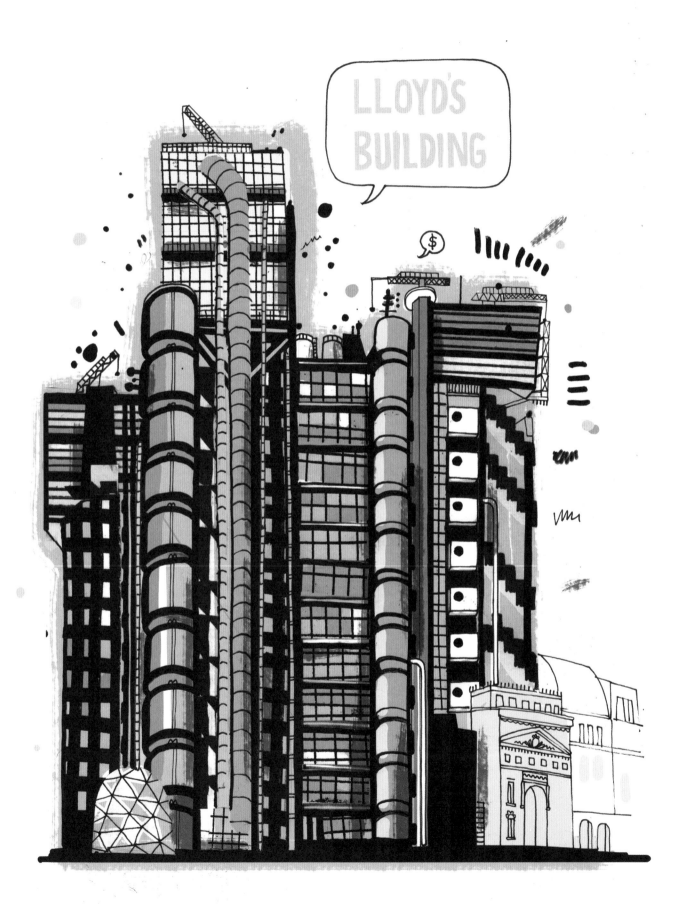

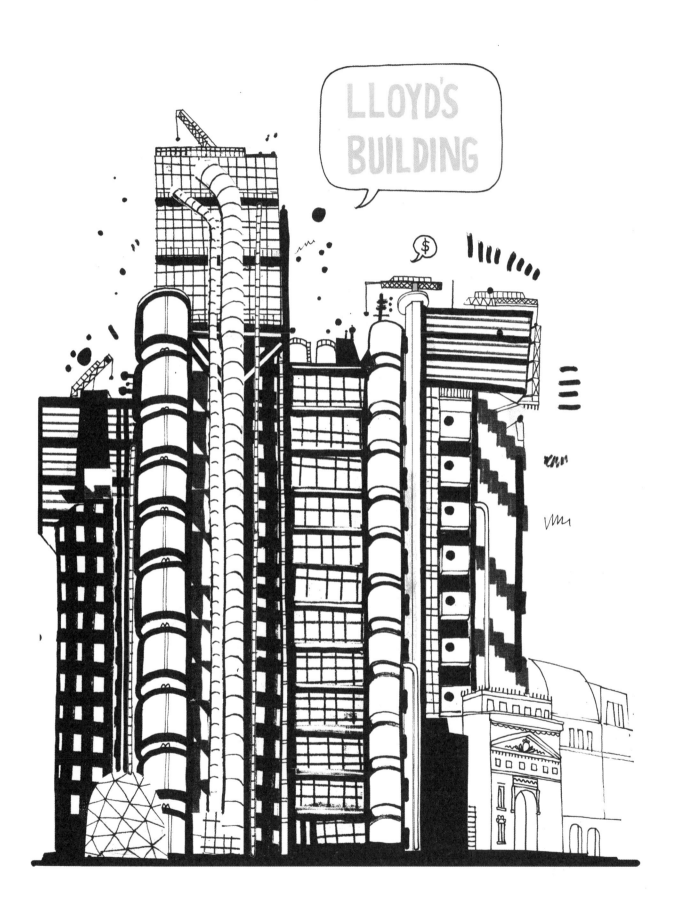

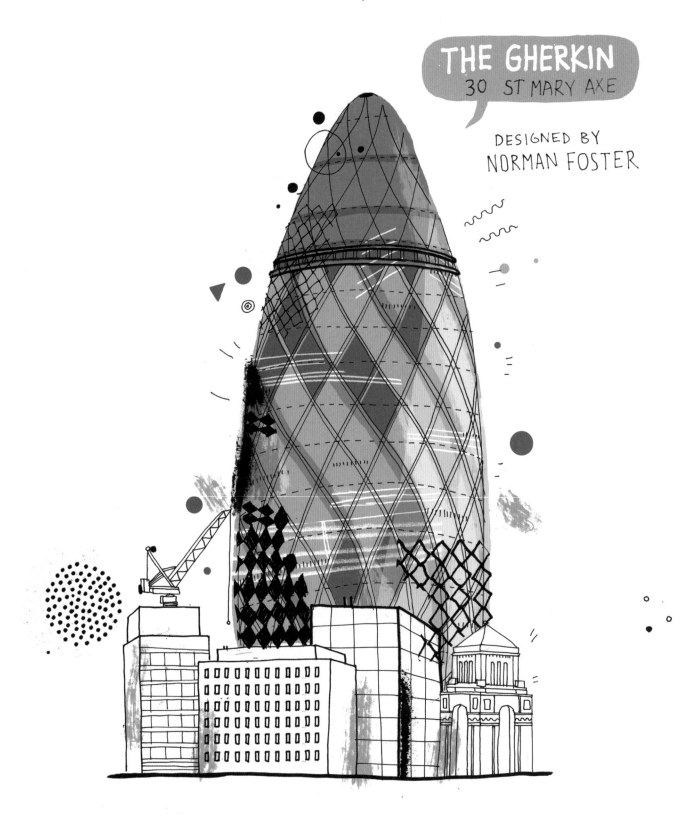

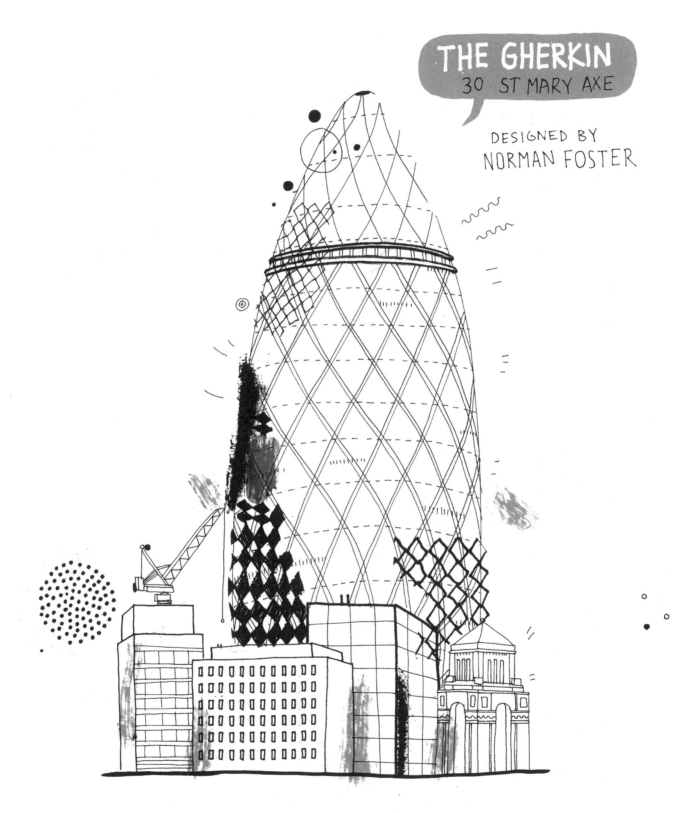

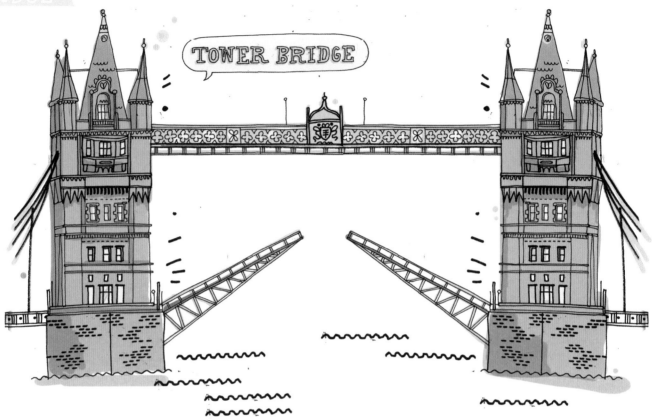

THE CROWN JEWELS HAVE BEEN HOUSED HERE SINCE THE REIGN OF HENRY III

TOWER OF LONDON

AT LEAST 6 RAVENS ARE KEPT AT THE TOWER IF THEY ARE ABSENT, THE KINGDOM WILL FALL!

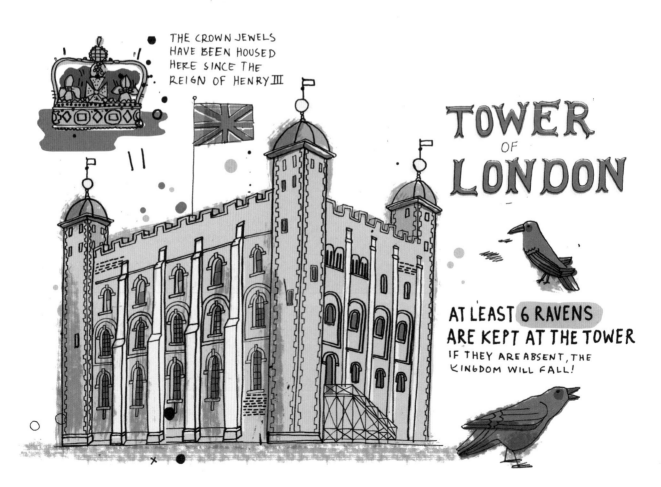

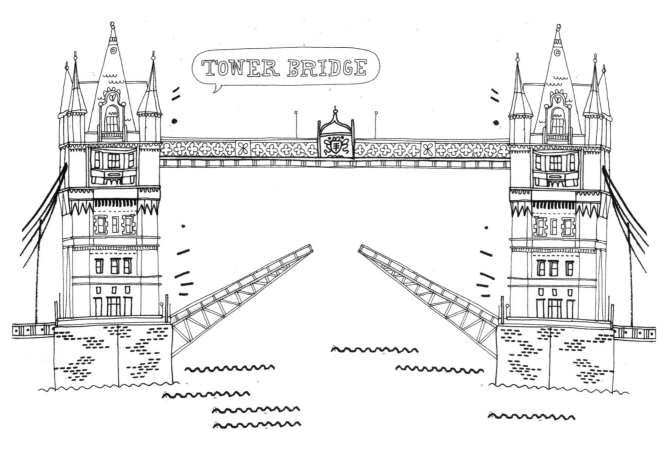

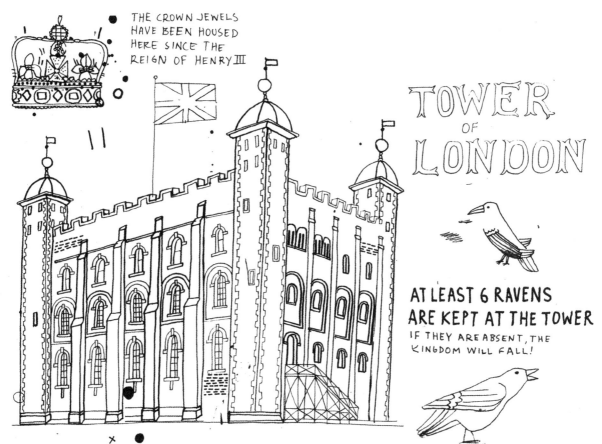

THE CROWN JEWELS HAVE BEEN HOUSED HERE SINCE THE REIGN OF HENRY III

TOWER OF LONDON

AT LEAST 6 RAVENS ARE KEPT AT THE TOWER
IF THEY ARE ABSENT, THE KINGDOM WILL FALL!

FOURNIER ST.

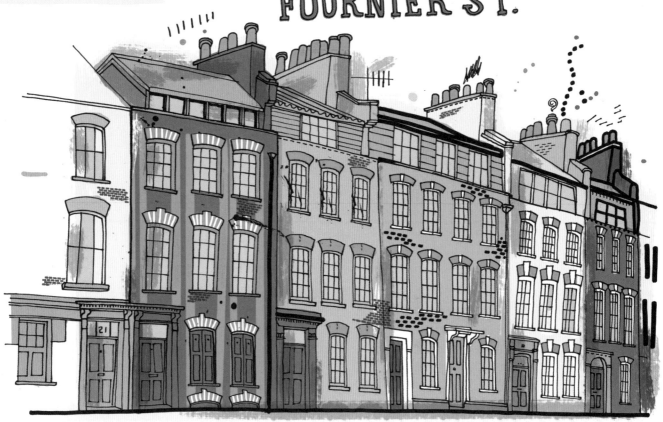

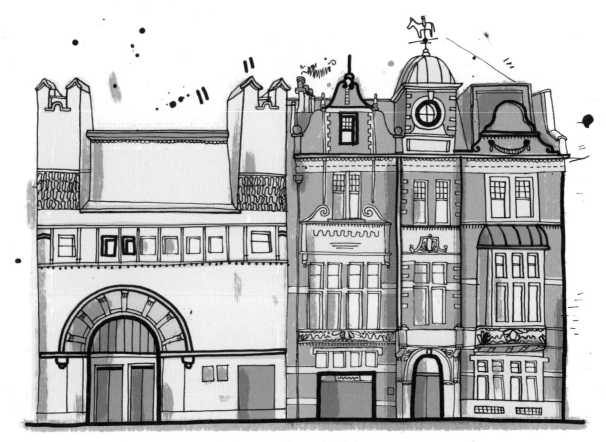

77-82 WHITECHAPEL HIGH ST

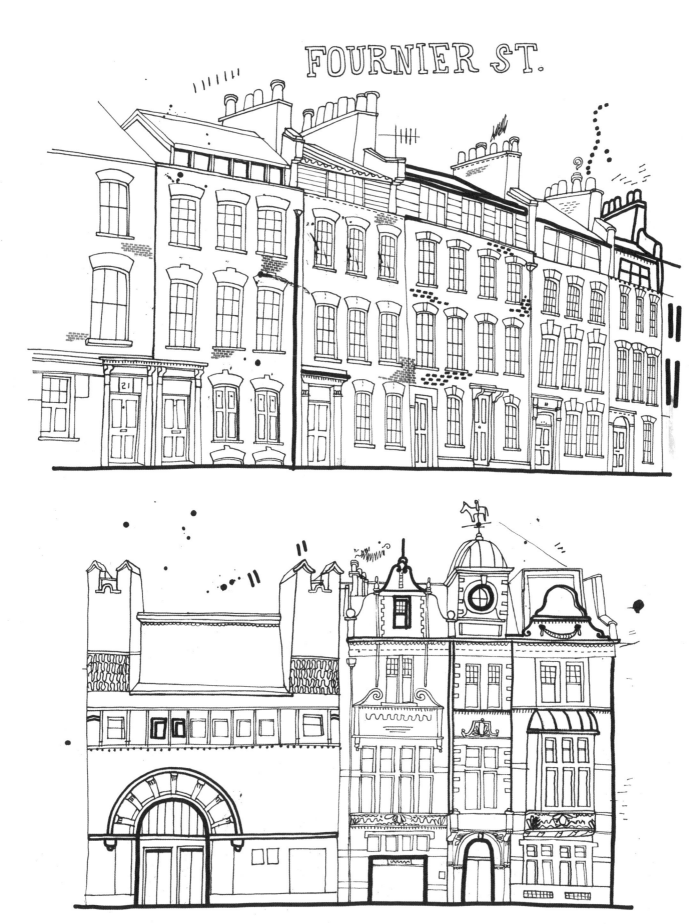

FOURNIER ST.

77-82 WHITECHAPEL HIGH ST

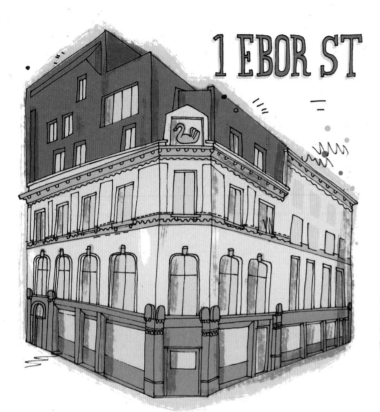

1 EBOR ST

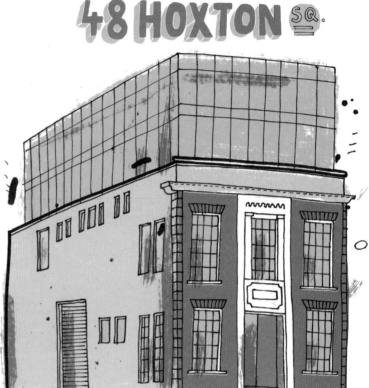

48 HOXTON SQ.

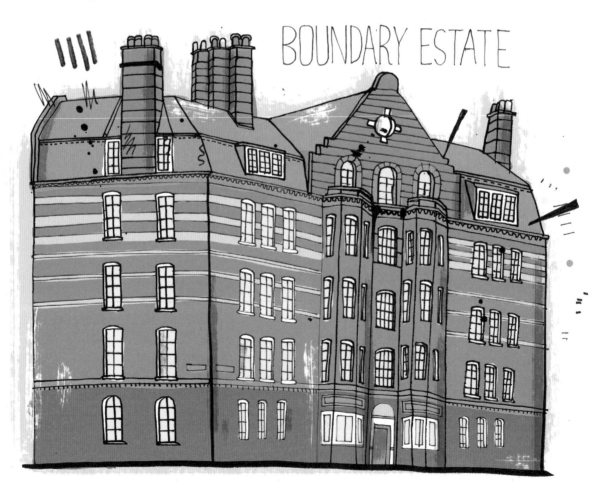

BOUNDARY ESTATE

1 EBOR ST

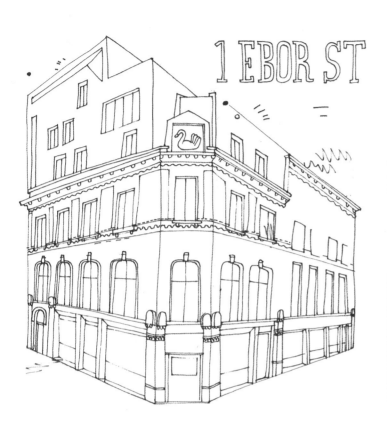

48 HOXTON SQ.

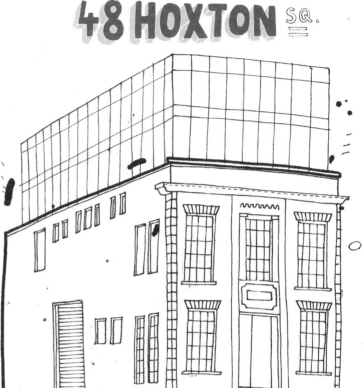

BOUNDARY ESTATE

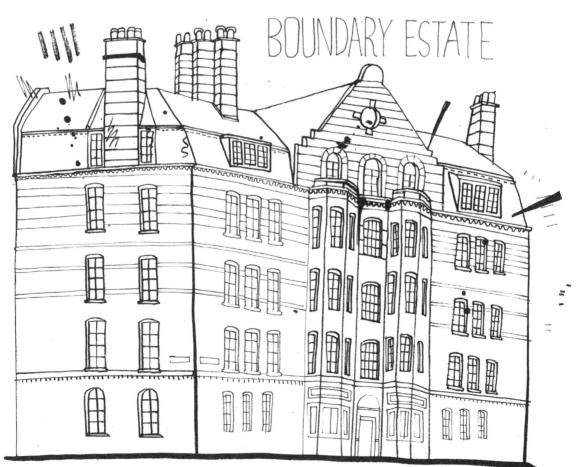

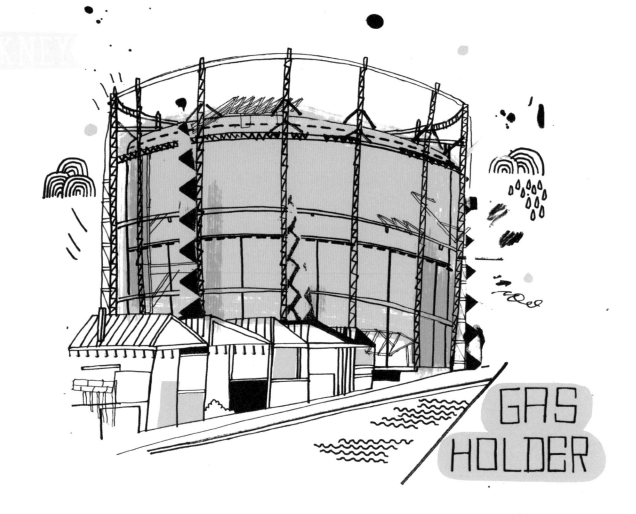

GAS HOLDER

7 QUEENSBRIDGE RD.

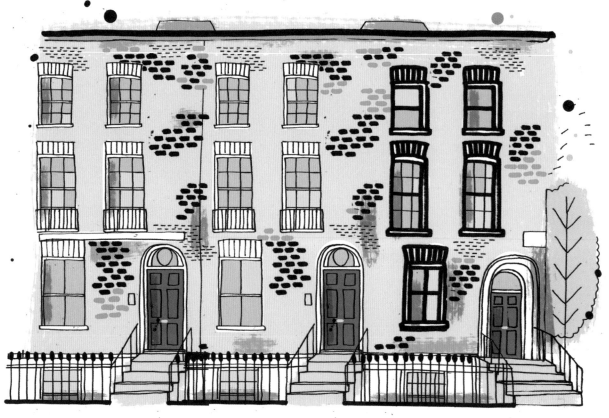

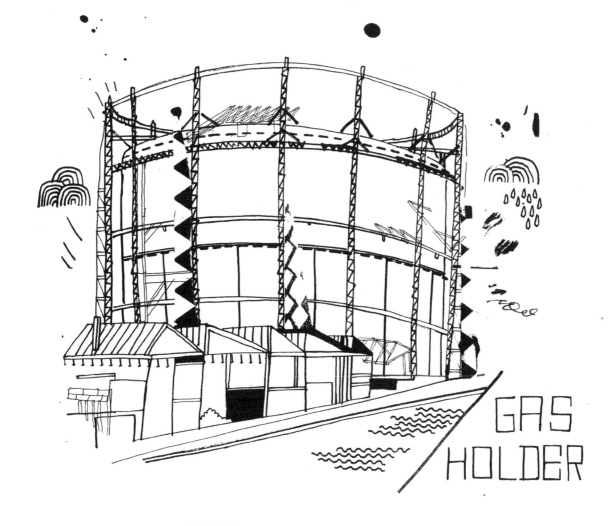

GAS
HOLDER

7 QUEENSBRIDGE RD.

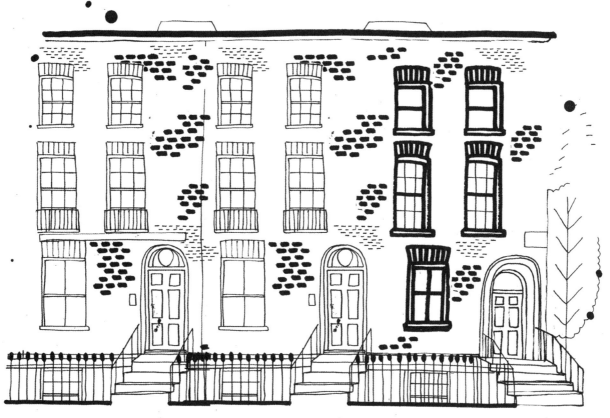

ON SUNDAY THE FLOWER MARKET FILLS THE STREET

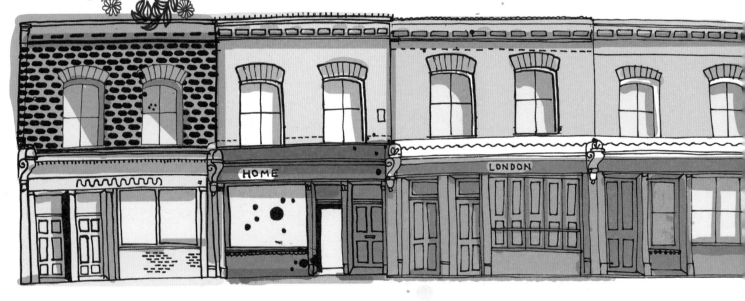

182 MARE ST.

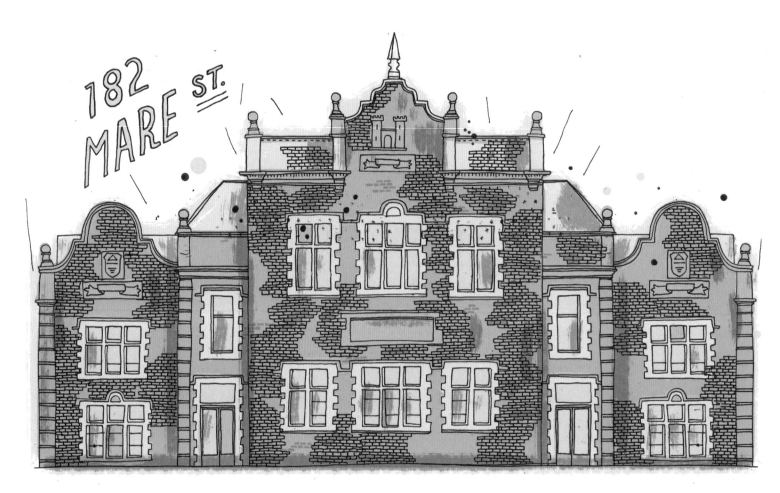

COLUMBIA RD.

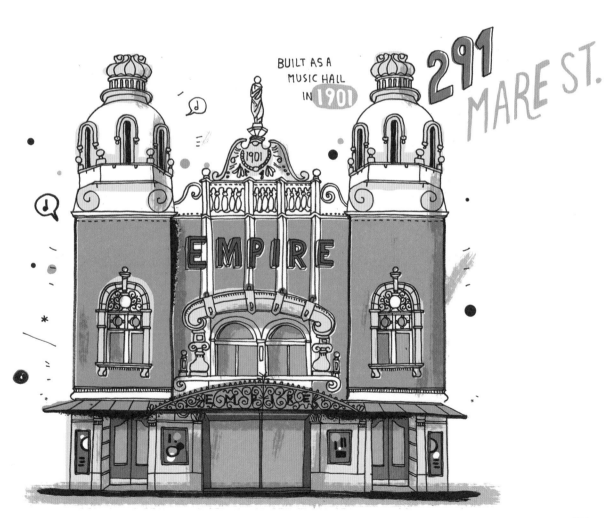

BUILT AS A MUSIC HALL IN 1901

291 MARE ST.

ON SUNDAY THE FLOWER MARKET FILLS THE STREET

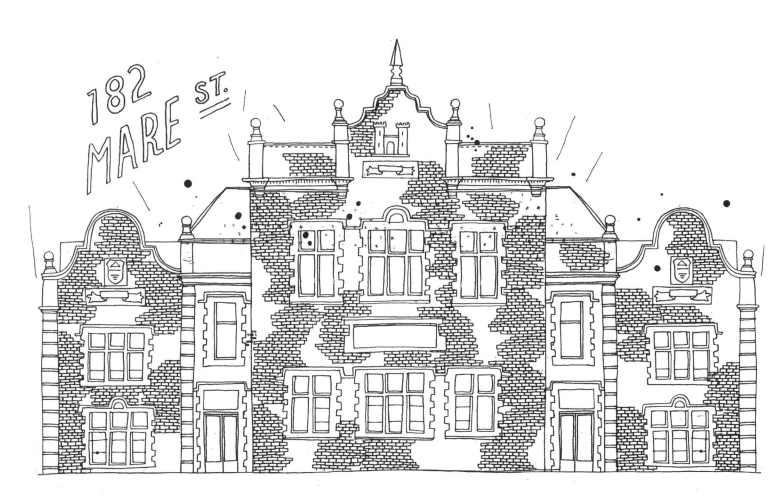

182 MARE ST.

COLUMBIA RD.

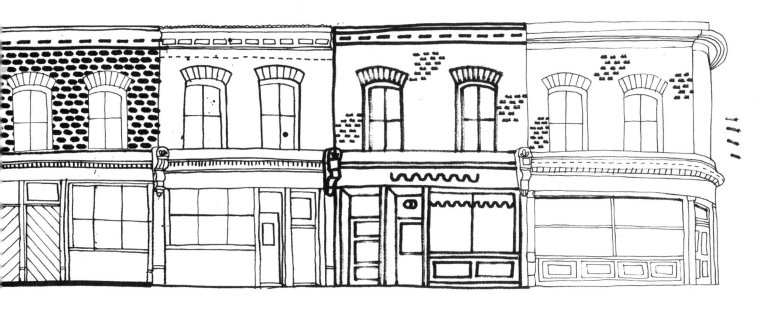

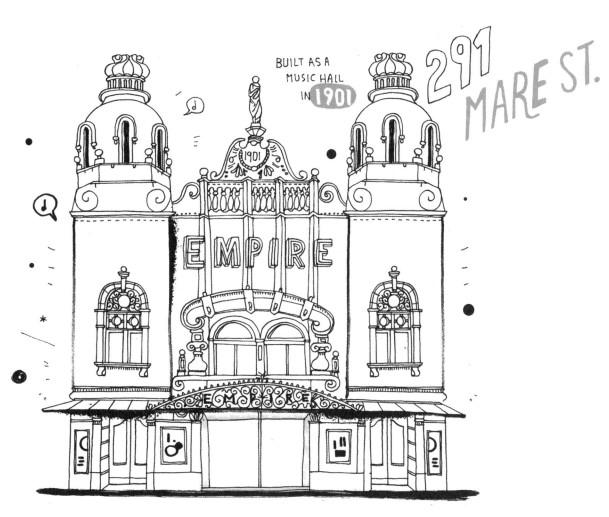

BUILT AS A MUSIC HALL IN 1901

291 MARE ST.

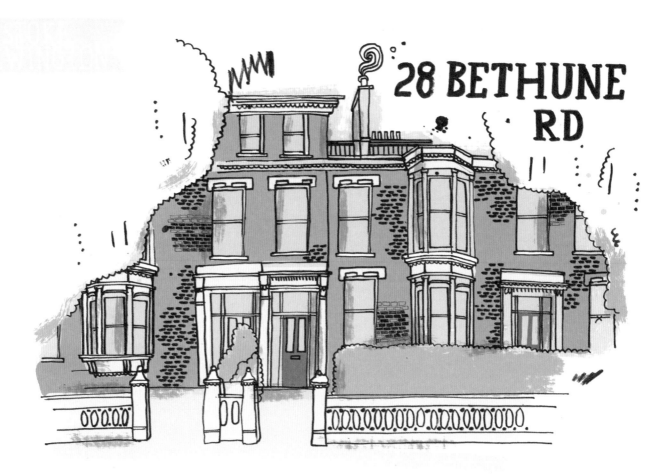

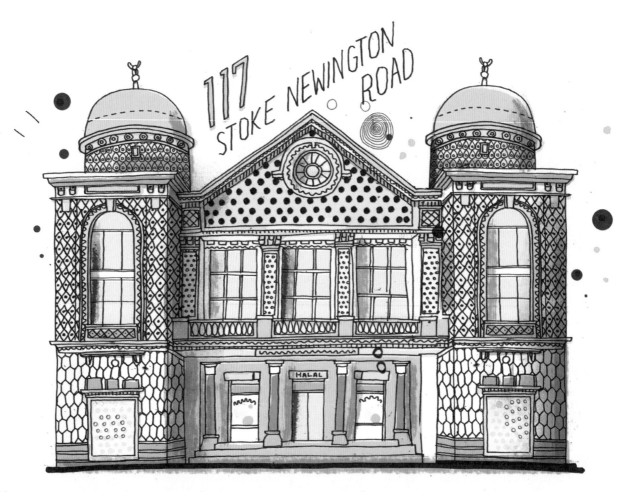

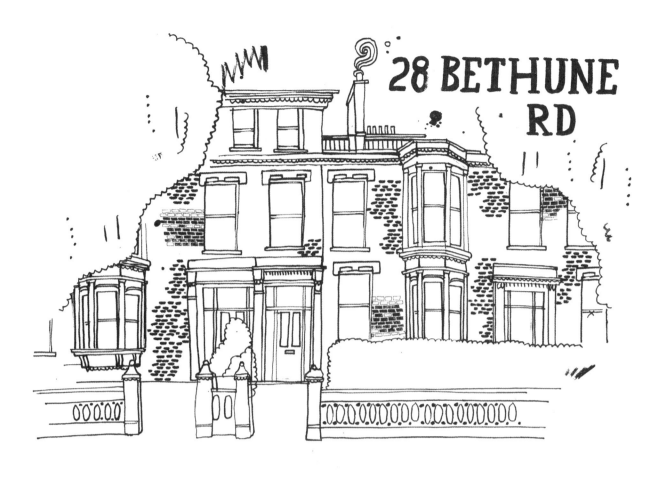

28 BETHUNE RD

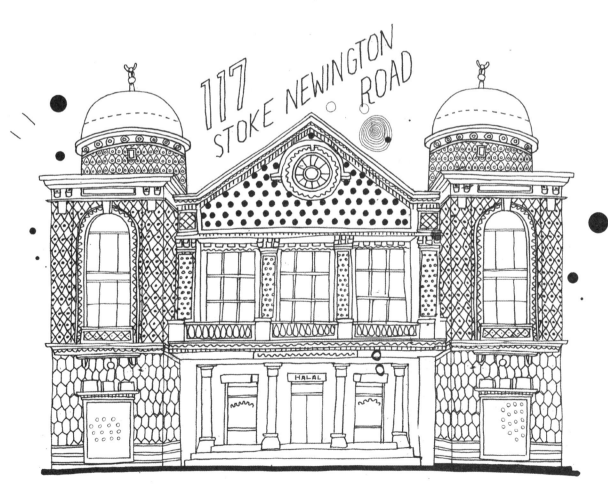

117 STOKE NEWINGTON ROAD

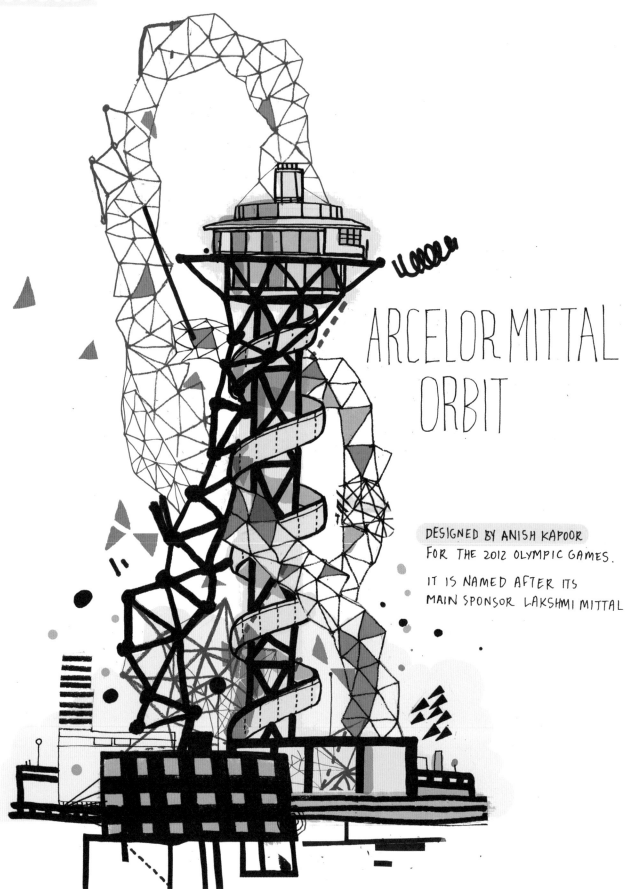

ARCELOR MITTAL ORBIT

DESIGNED BY ANISH KAPOOR
FOR THE 2012 OLYMPIC GAMES.

IT IS NAMED AFTER ITS
MAIN SPONSOR LAKSHMI MITTAL

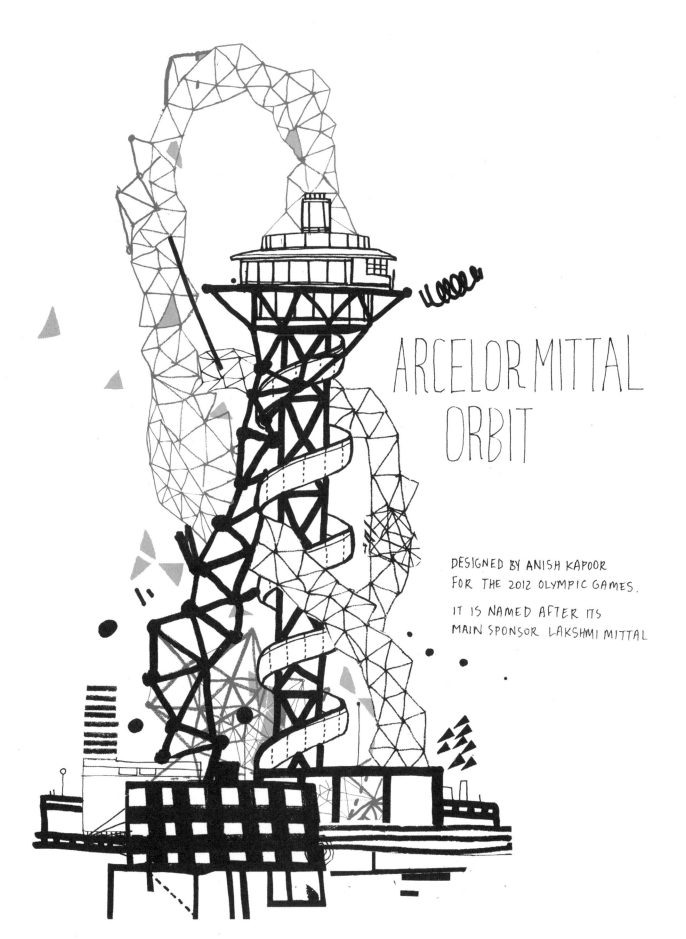

ARCELOR MITTAL
ORBIT

DESIGNED BY ANISH KAPOOR
FOR THE 2012 OLYMPIC GAMES.

IT IS NAMED AFTER ITS
MAIN SPONSOR LAKSHMI MITTAL

81-85 ANTILL RD.

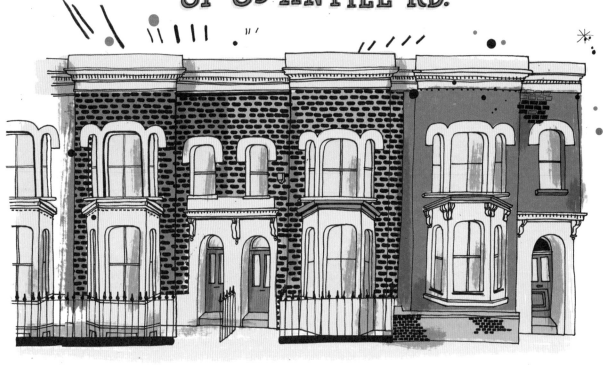

490 COMMERCIAL RD.

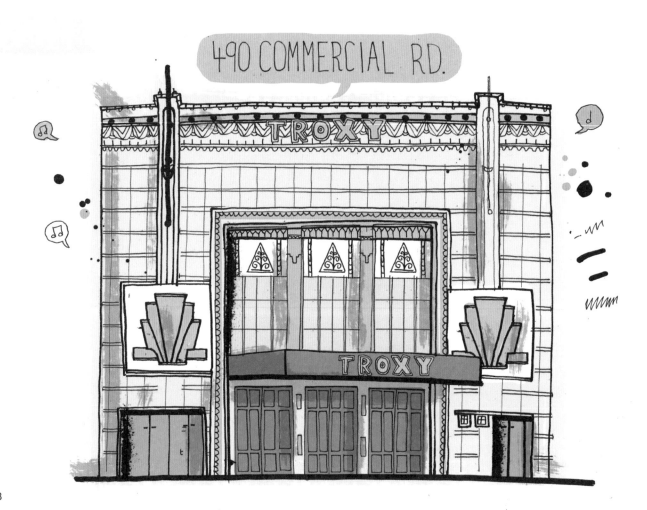

81-85 ANTILL RD.

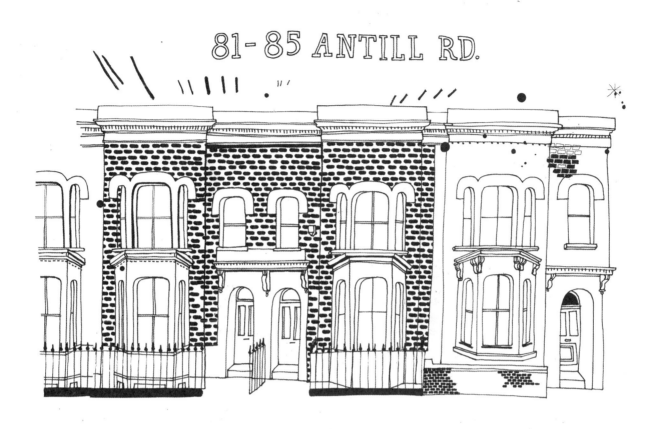

490 COMMERCIAL RD.

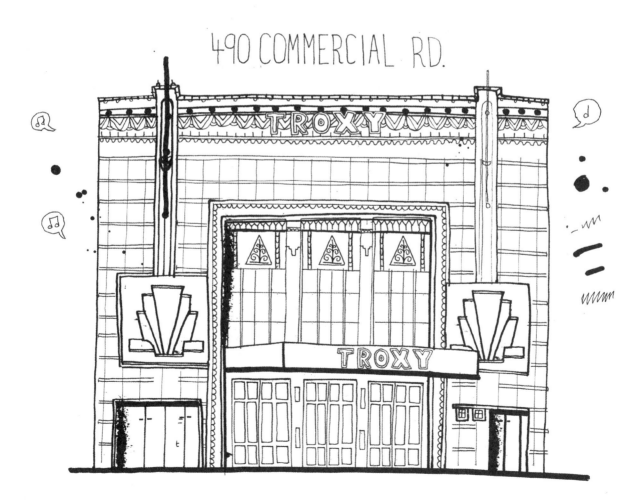

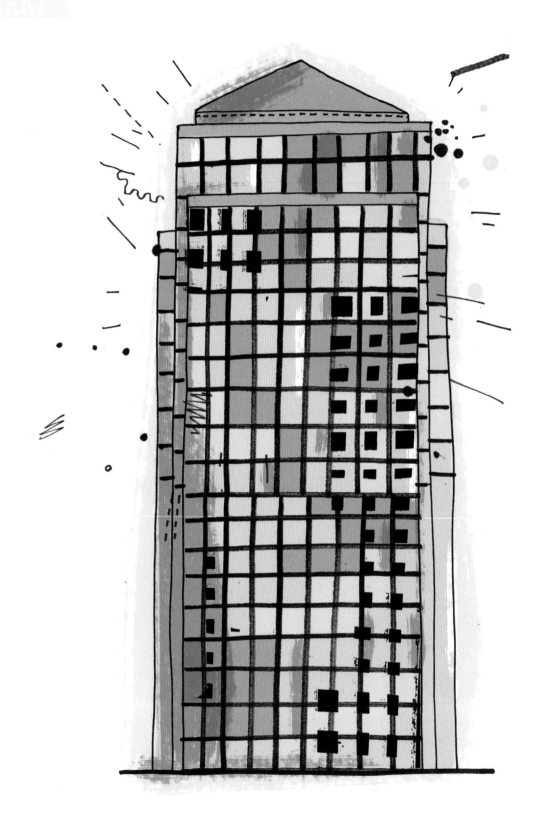

ONE CANADA SQ.

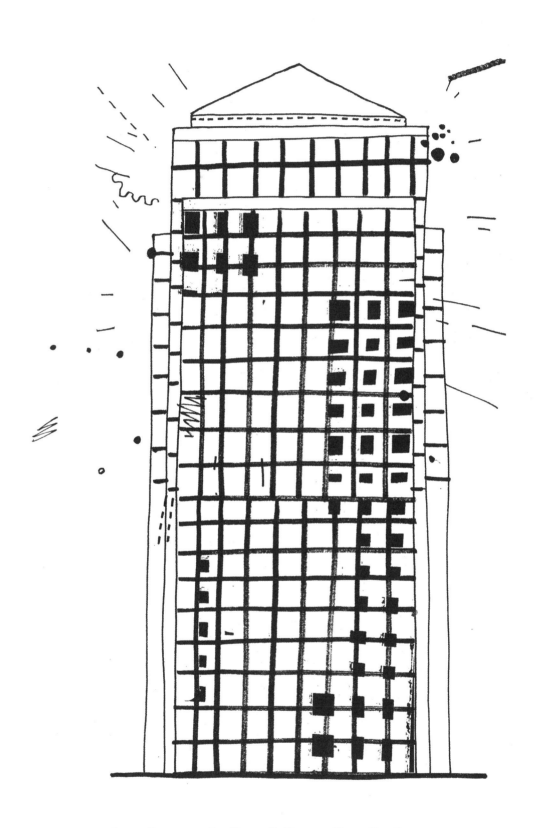

ONE CANADA SQ.

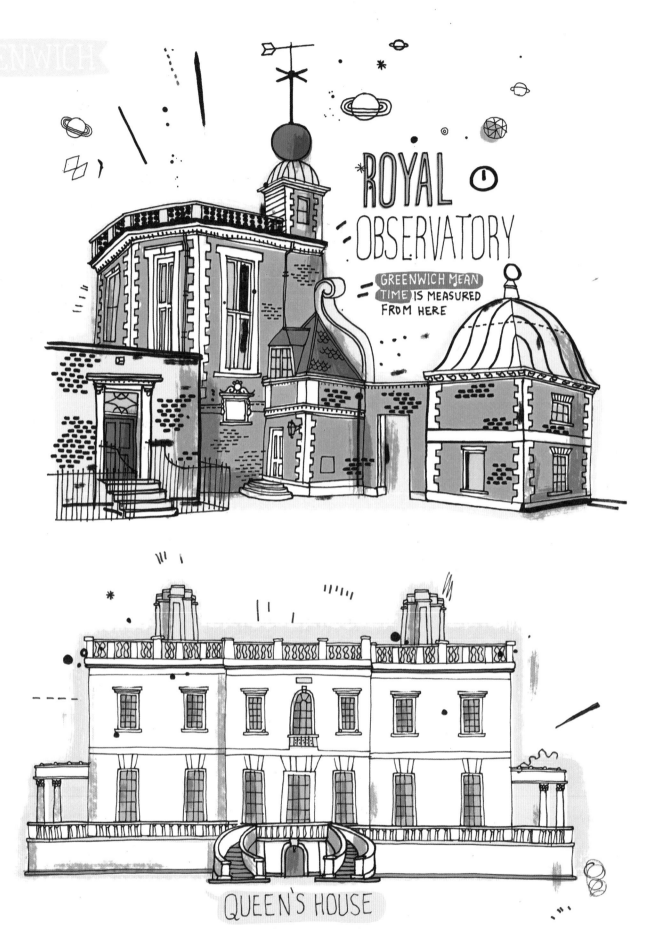

ROYAL OBSERVATORY

GREENWICH MEAN TIME IS MEASURED FROM HERE

QUEEN'S HOUSE

PART OF THE NATIONAL MARITIME MUSEUM
THE FORMER ROYAL RESIDENCE DESIGNED BY INIGO JONES
THE FIRST CONSCIOUSLY CLASSICAL BUILDING BUILT IN ENGLAND

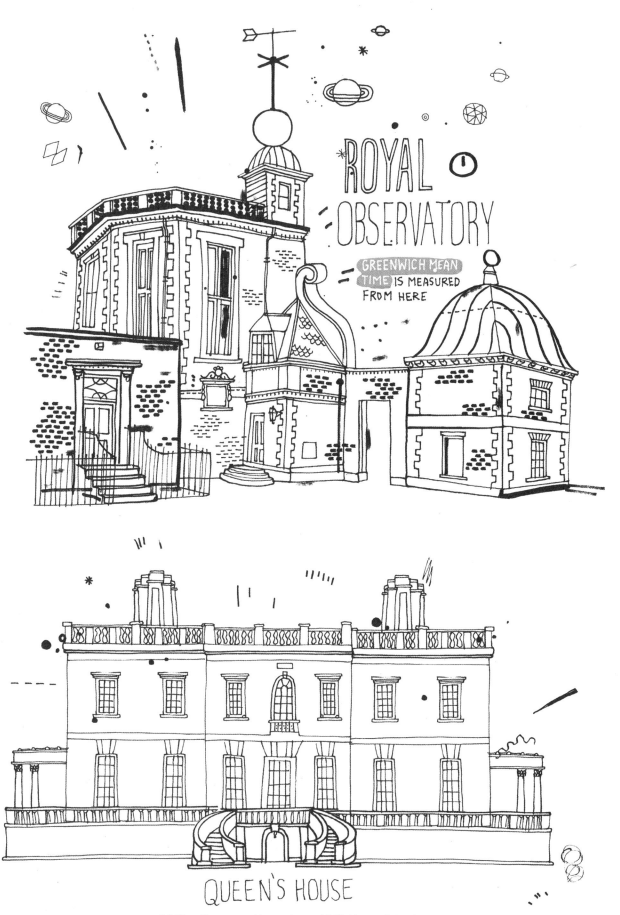

ROYAL OBSERVATORY

GREENWICH MEAN TIME IS MEASURED FROM HERE

QUEEN'S HOUSE

PART OF THE NATIONAL MARITIME MUSEUM
THE FORMER ROYAL RESIDENCE DESIGNED BY INIGO JONES
THE FIRST CONSCIOUSLY CLASSICAL BUILDING BUILT IN ENGLAND

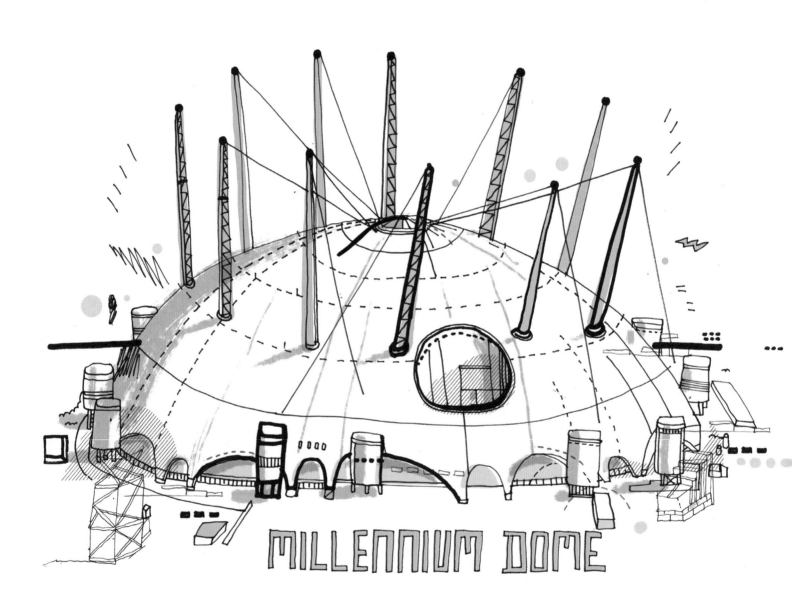

MILLENNIUM DOME

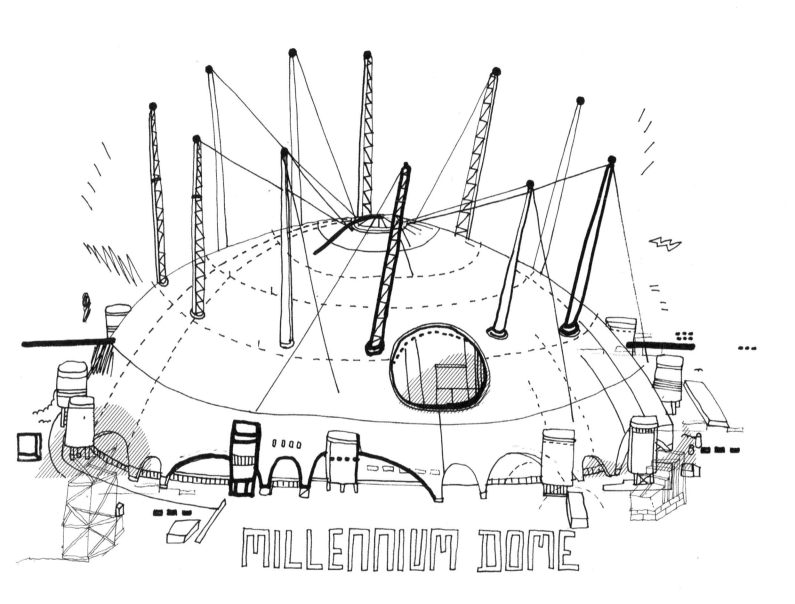

MILLENNIUM DOME

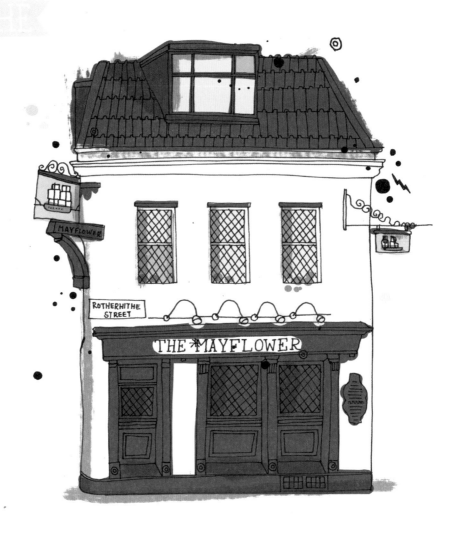

ROTHERHITHE STREET

THE MAYFLOWER

MAYFLOWER

SOUTH
LONDON
GALLERY

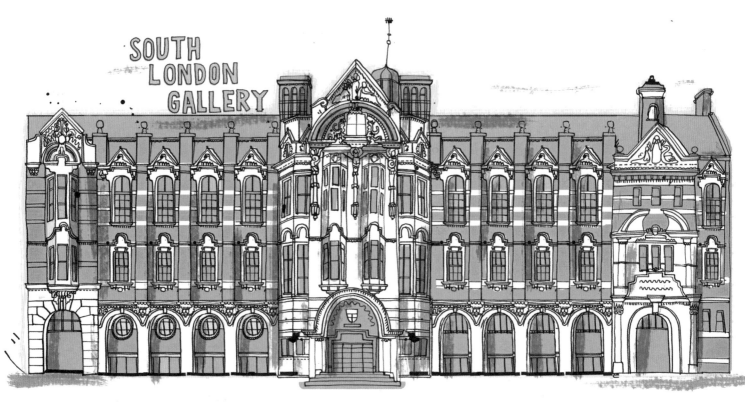

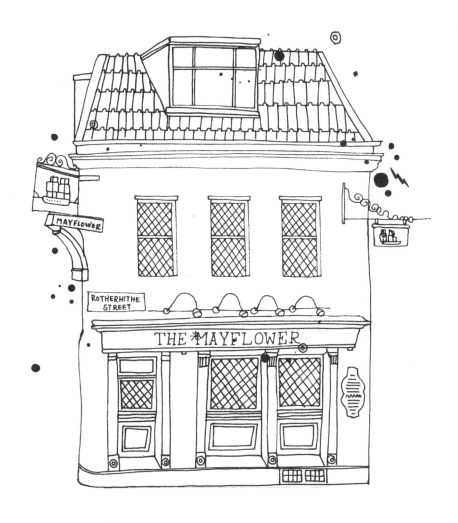

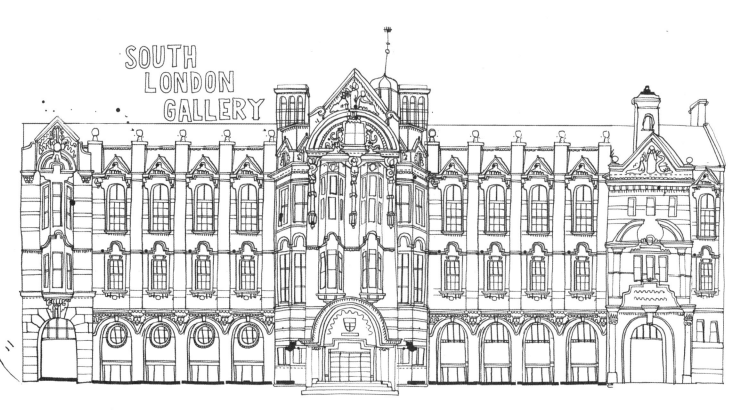

SOUTH
LONDON
GALLERY

CITY HALL

DESIGNED BY
NORMAN FOSTER
IT COST
£43 MILLION
TO CONSTRUCT
AND WAS COMPLETED
IN 2002

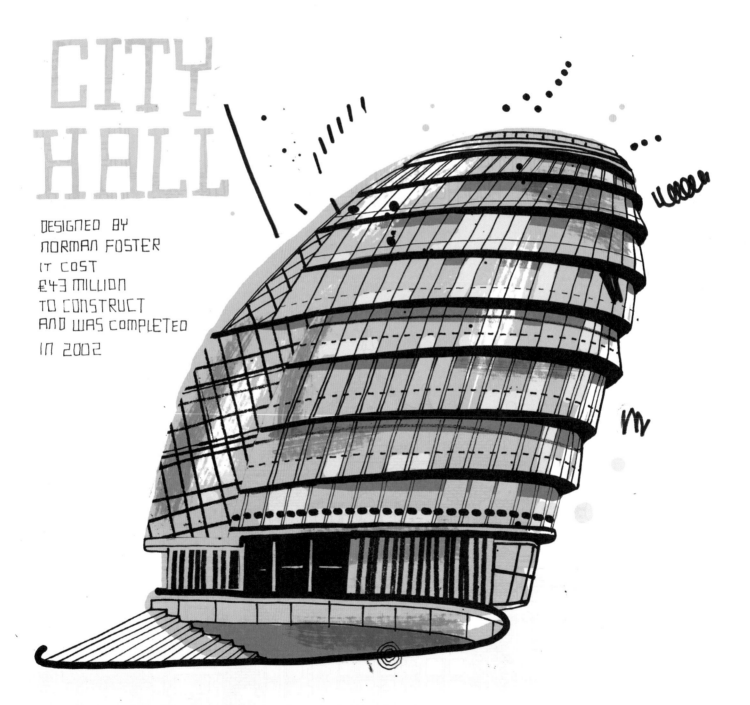

CITY HALL

DESIGNED BY
NORMAN FOSTER
IT COST
£43 MILLION
TO CONSTRUCT
AND WAS COMPLETED
IN 2002

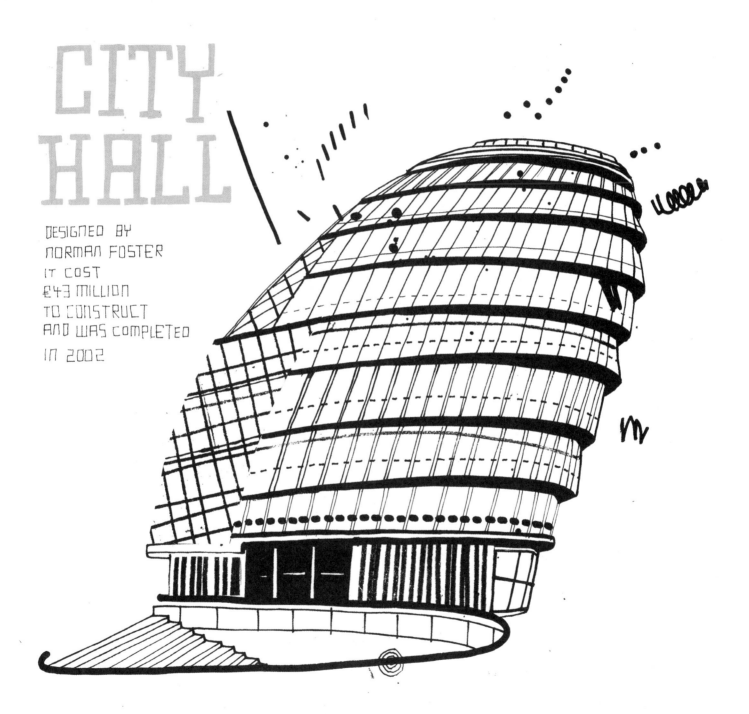

LONDON BRIDGE
UNDERGROUND STATION

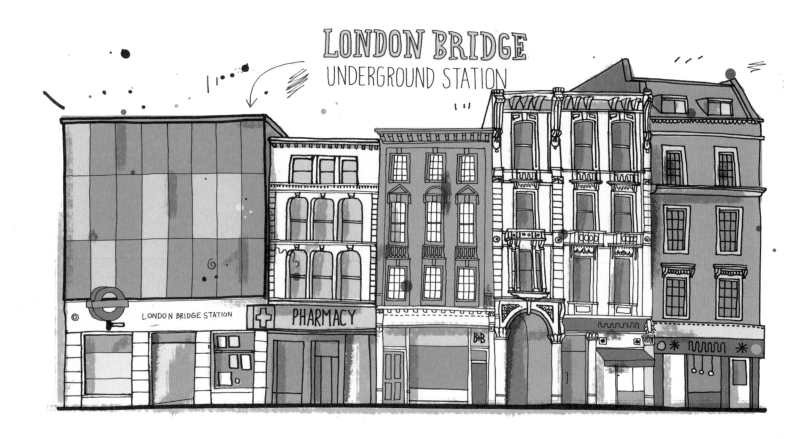

LONDON BRIDGE STATION

PHARMACY

B&B

BOROUGH MARKET

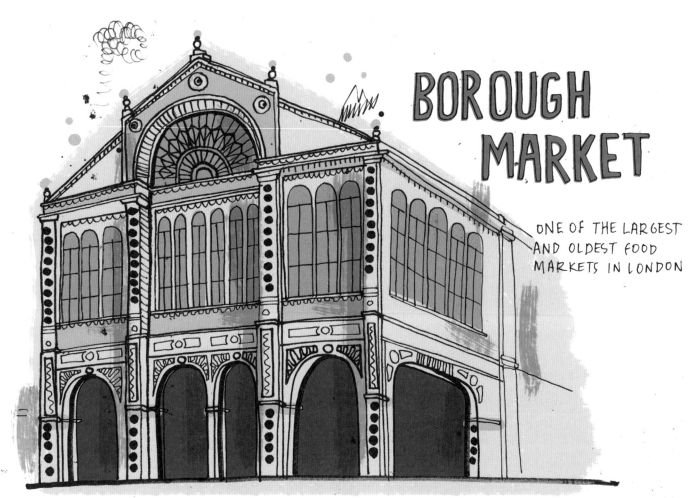

ONE OF THE LARGEST AND OLDEST FOOD MARKETS IN LONDON

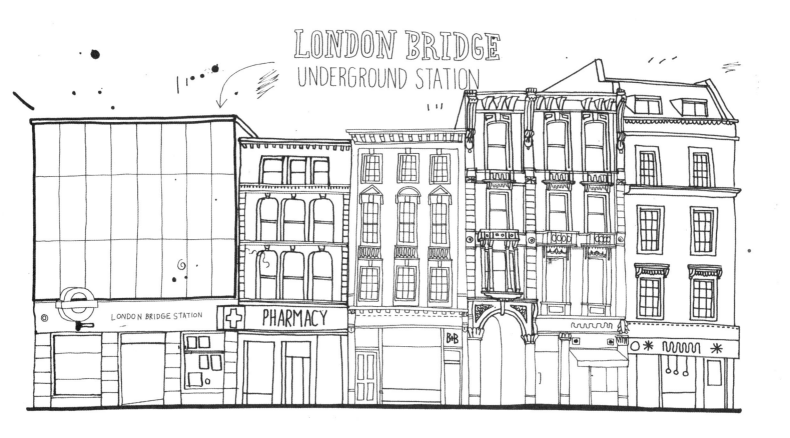

LONDON BRIDGE
UNDERGROUND STATION

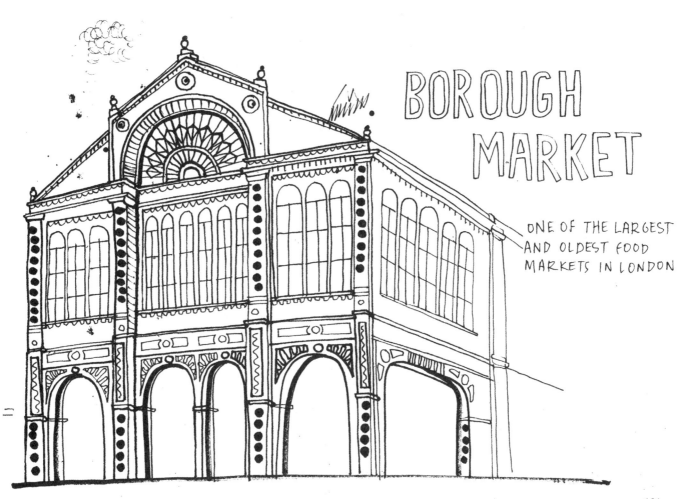

BOROUGH MARKET

ONE OF THE LARGEST AND OLDEST FOOD MARKETS IN LONDON

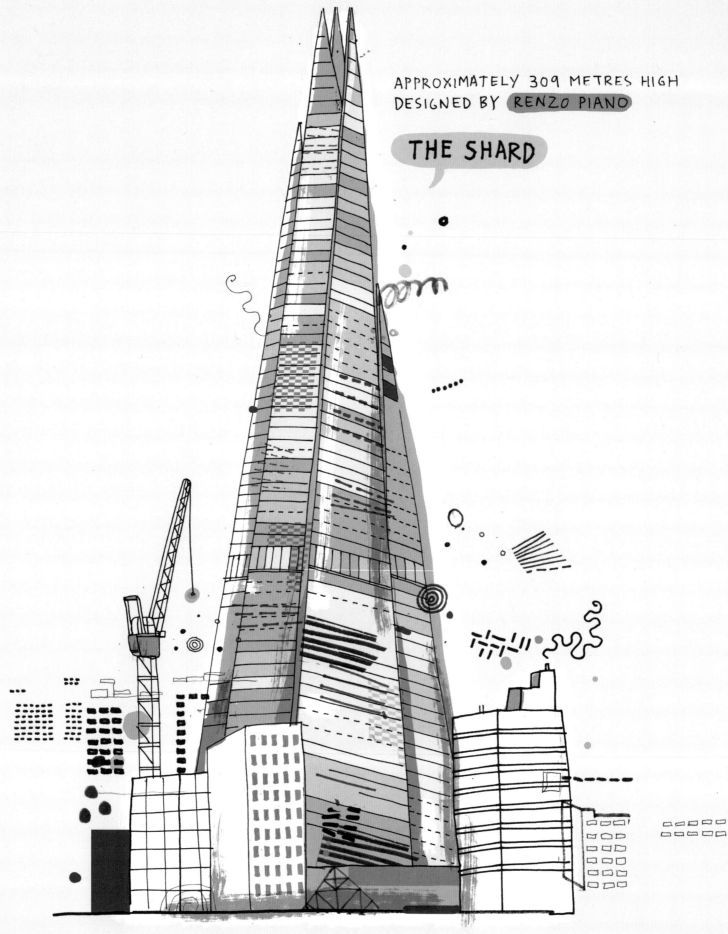

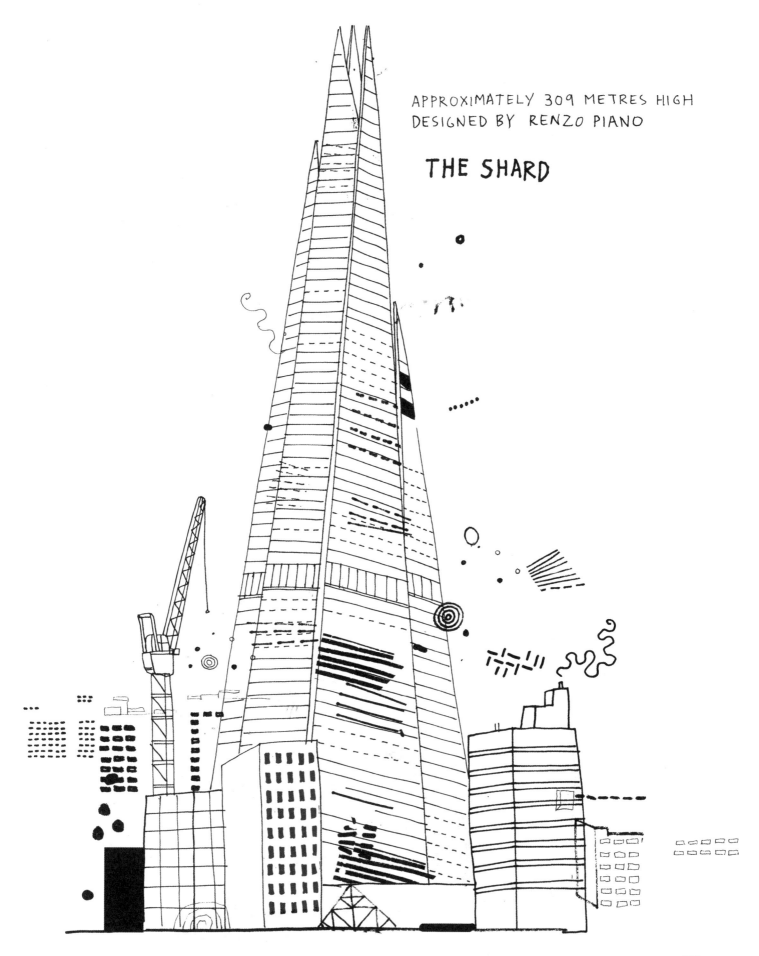

APPROXIMATELY 309 METRES HIGH
DESIGNED BY RENZO PIANO

THE SHARD

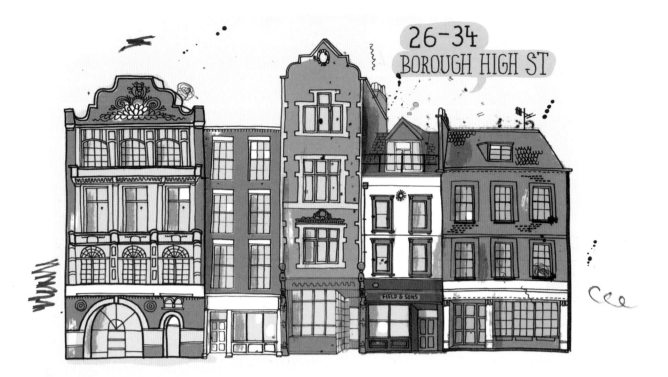

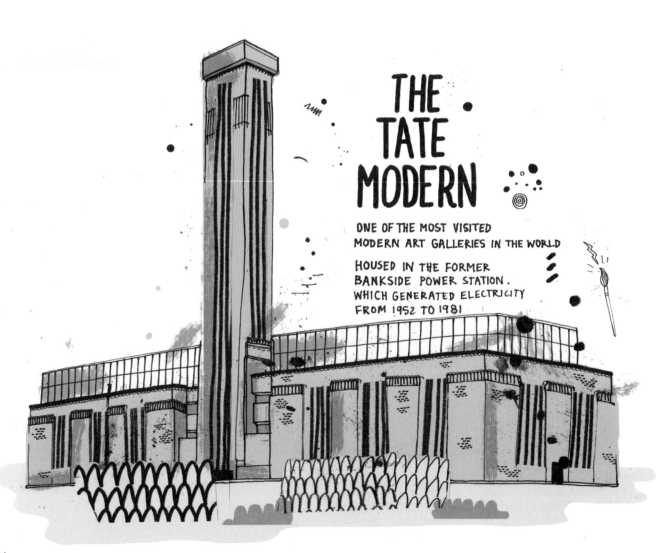

THE TATE MODERN

ONE OF THE MOST VISITED
MODERN ART GALLERIES IN THE WORLD

HOUSED IN THE FORMER
BANKSIDE POWER STATION.
WHICH GENERATED ELECTRICITY
FROM 1952 TO 1981

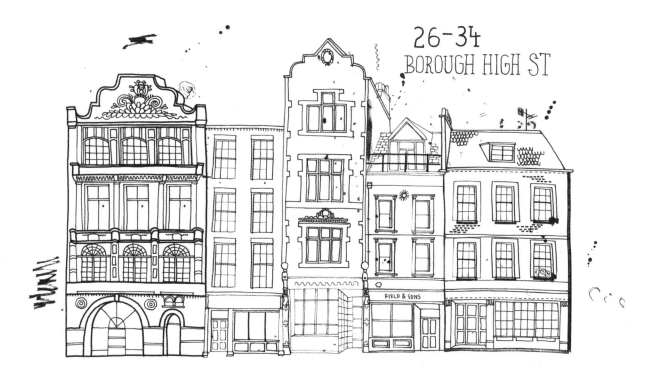

26-34
BOROUGH HIGH ST

FIELD & SONS

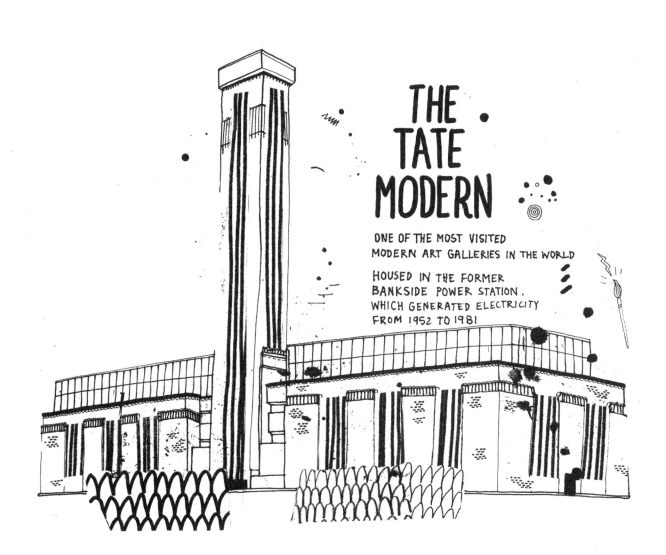

THE TATE MODERN

ONE OF THE MOST VISITED
MODERN ART GALLERIES IN THE WORLD

HOUSED IN THE FORMER
BANKSIDE POWER STATION.
WHICH GENERATED ELECTRICITY
FROM 1952 TO 1981

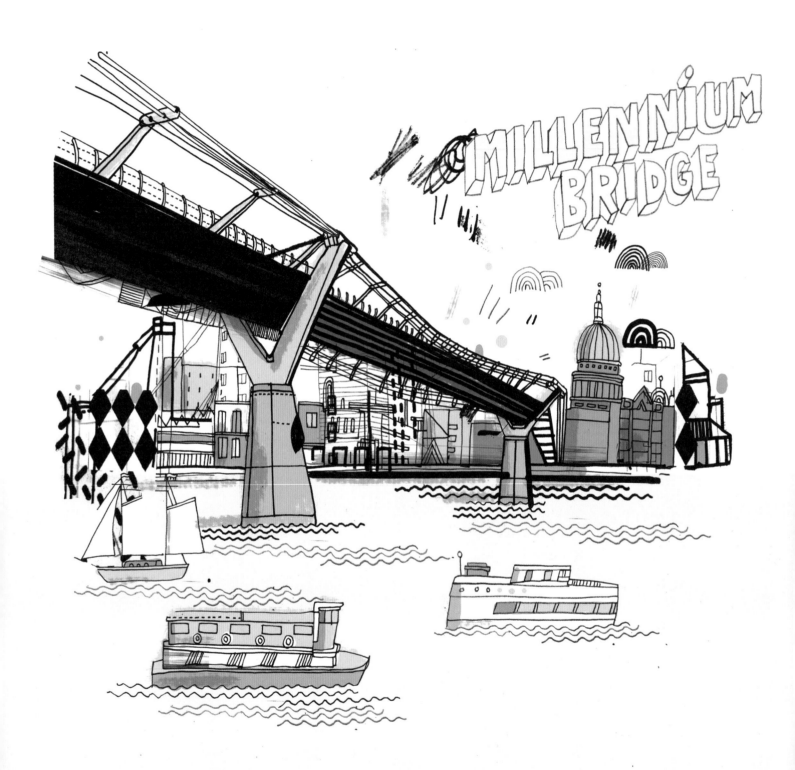

MILLENNIUM BRIDGE

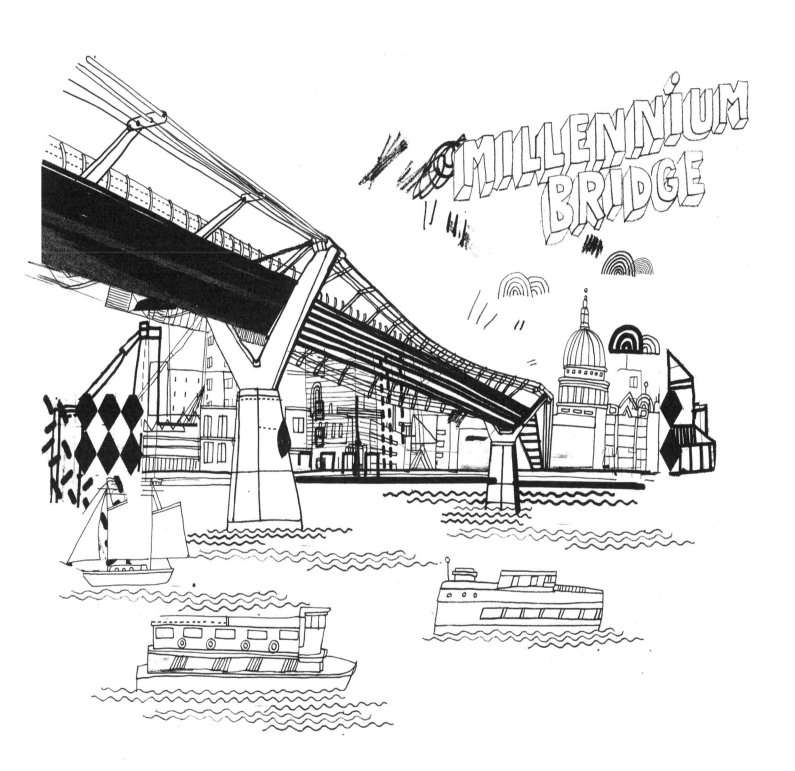

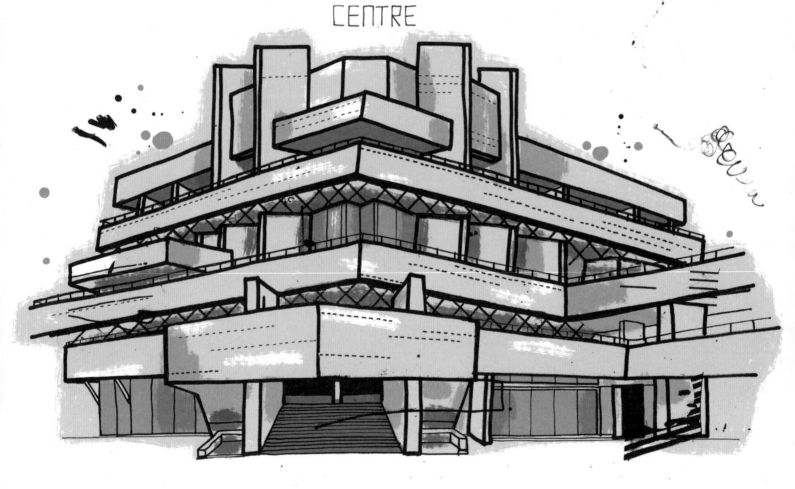

SOUTHBANK
CENTRE

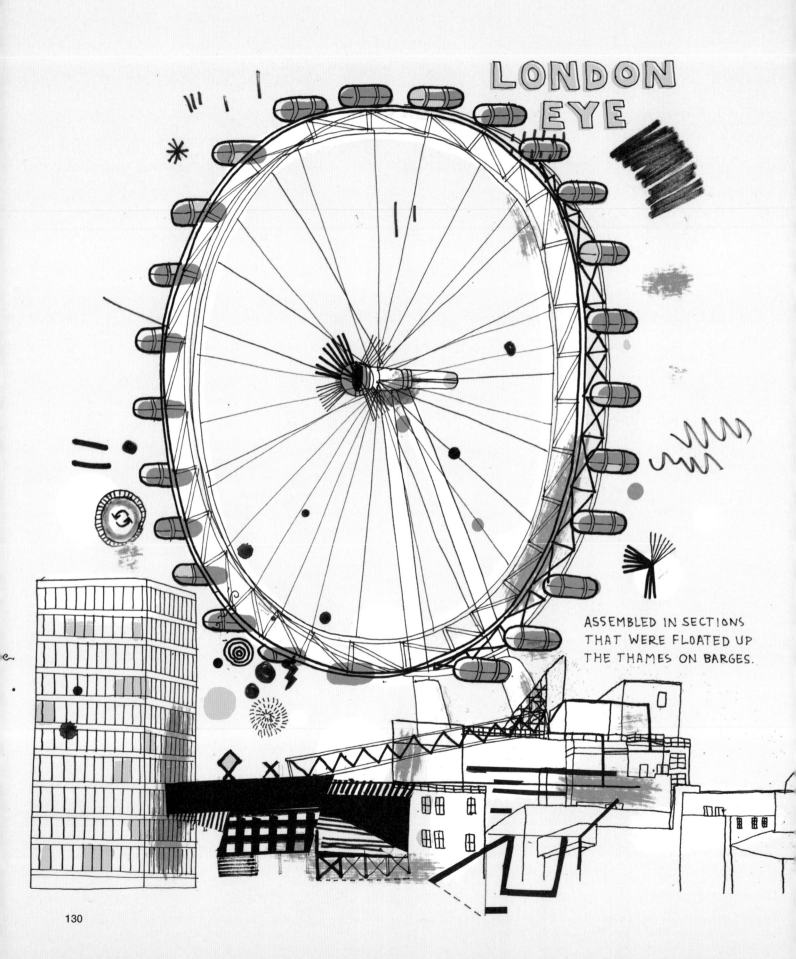

ASSEMBLED IN SECTIONS
THAT WERE FLOATED UP
THE THAMES ON BARGES.

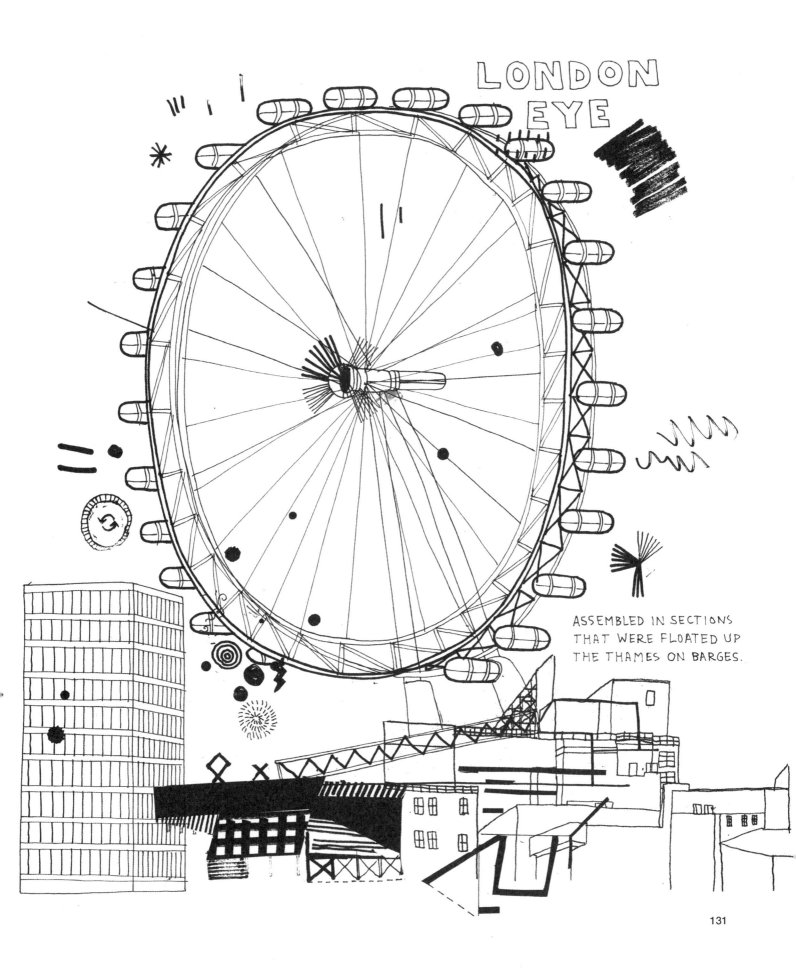

LONDON EYE

ASSEMBLED IN SECTIONS
THAT WERE FLOATED UP
THE THAMES ON BARGES.

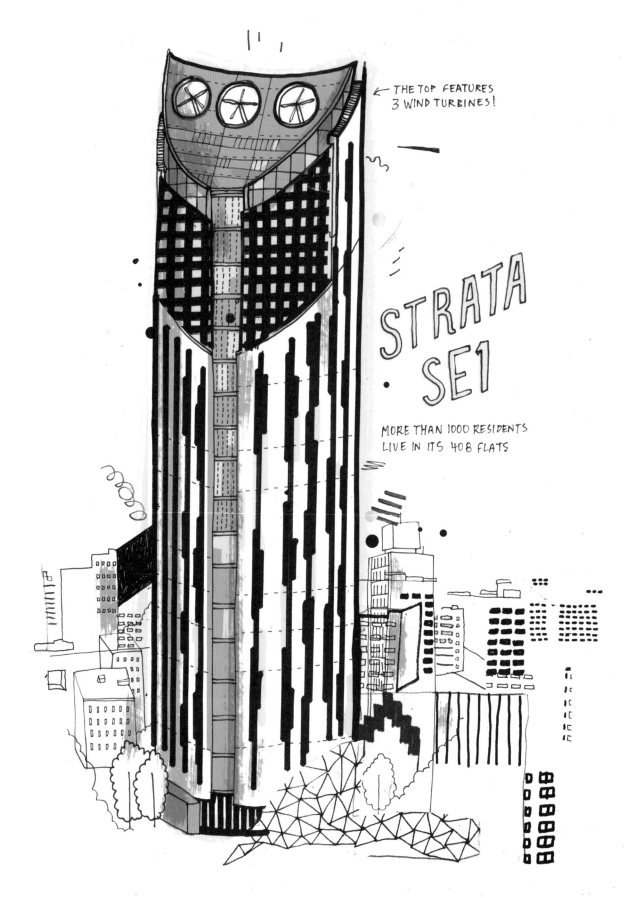

THE TOP FEATURES
3 WIND TURBINES!

STRATA
SE1

MORE THAN 1000 RESIDENTS
LIVE IN ITS 408 FLATS

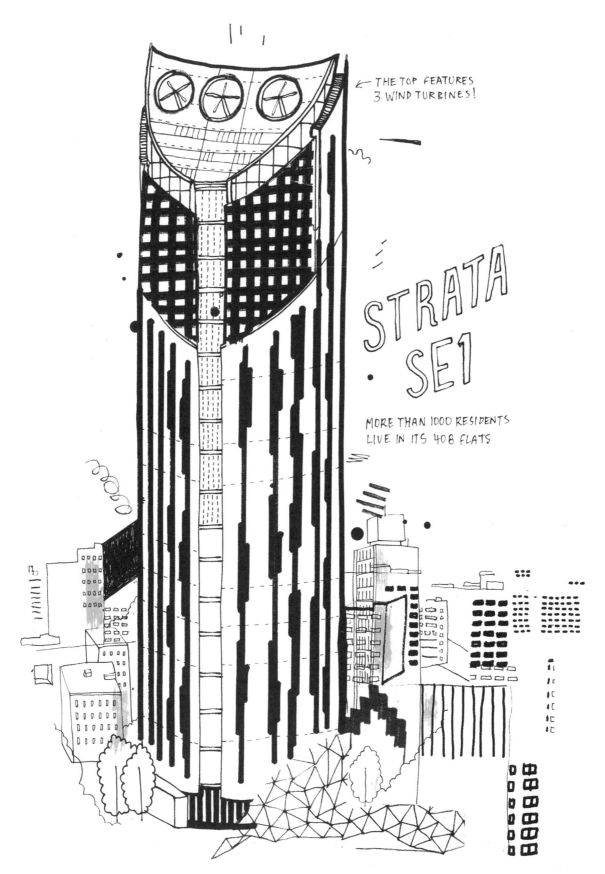

THE TOP FEATURES
3 WIND TURBINES!

STRATA
SE1

MORE THAN 1000 RESIDENTS
LIVE IN ITS 408 FLATS

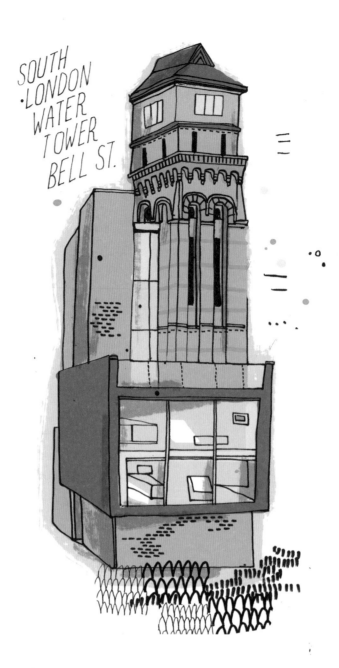

SOUTH
LONDON
WATER
TOWER
BELL ST.

CORNER OF
PENROSE ST.
&
WALWORTH RD.

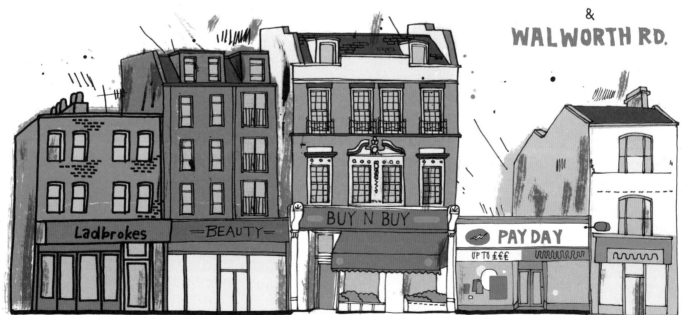

Ladbrokes BEAUTY BUY N BUY PAY DAY
UP TO £££

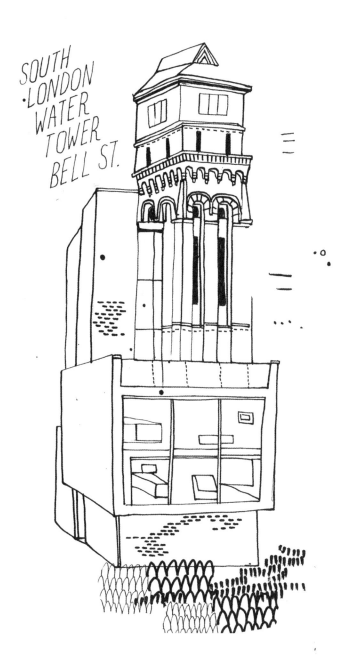

SOUTH
·LONDON
WATER
TOWER
BELL ST.

CORNER OF
PENROSE ST.
&
WALWORTH RD.

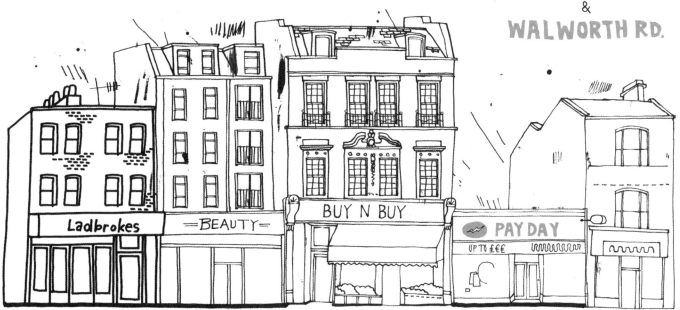

Ladbrokes =BEAUTY= BUY N BUY PAY DAY
UP TO £££

SOUTHBANK HOUSE

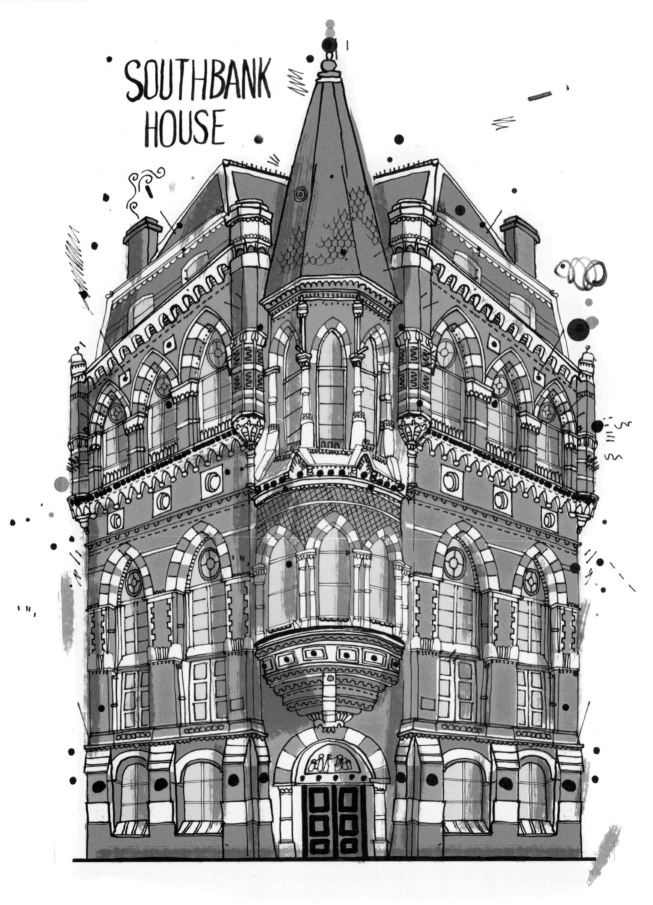

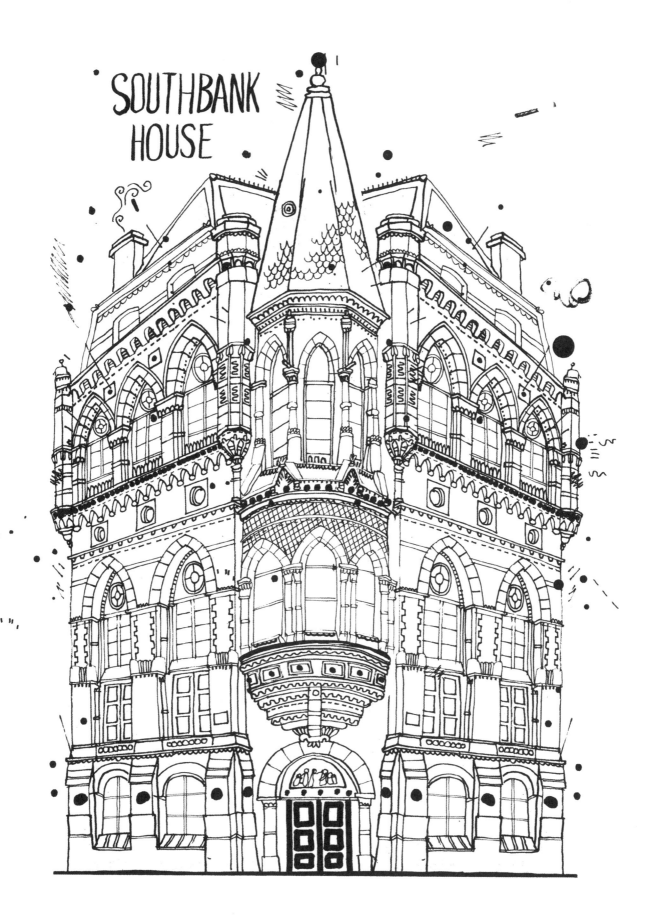

SOUTHBANK
HOUSE

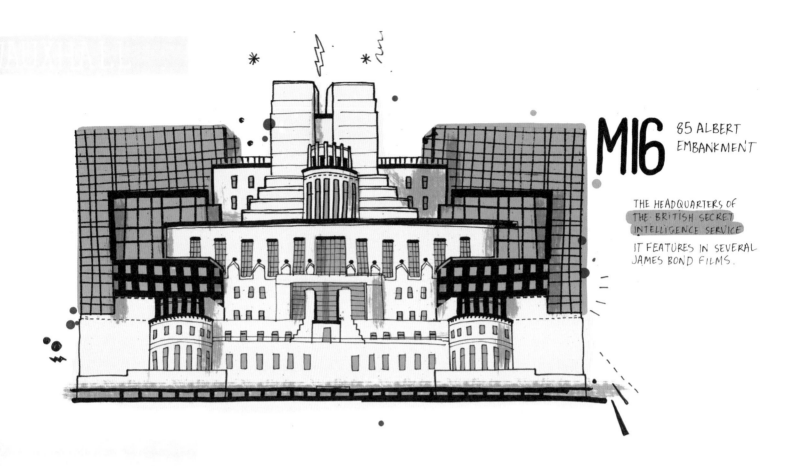

MI6
85 ALBERT EMBANKMENT

THE HEADQUARTERS OF THE BRITISH SECRET INTELLIGENCE SERVICE

IT FEATURES IN SEVERAL JAMES BOND FILMS.

BATTERSEA POWER STATION

DECOMMISSIONED COAL-FIRED POWER STATION MADE FAMOUS ON THE COVER OF PINK FLOYD'S ALBUM *ANIMALS*

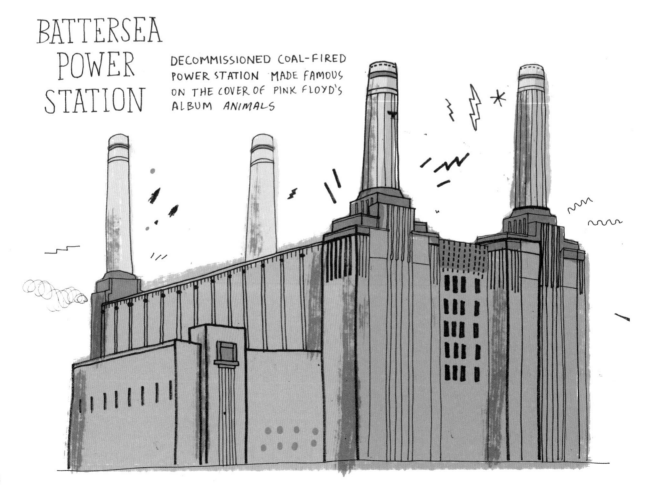

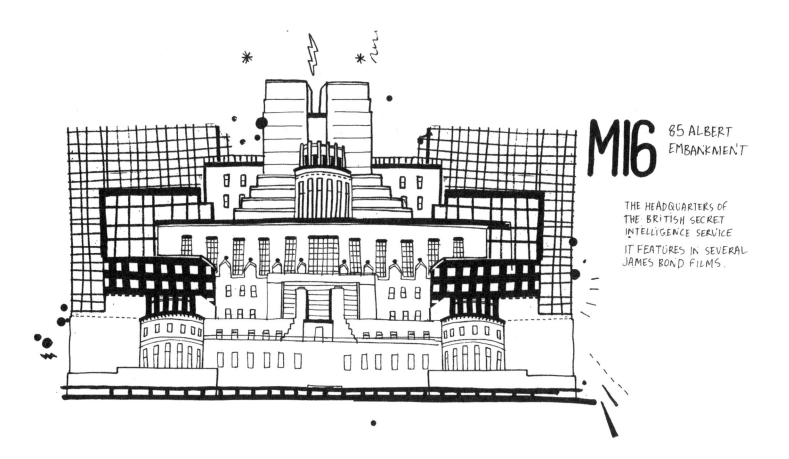

MI6

85 ALBERT EMBANKMENT

THE HEADQUARTERS OF THE BRITISH SECRET INTELLIGENCE SERVICE

IT FEATURES IN SEVERAL JAMES BOND FILMS.

BATTERSEA POWER STATION

DECOMMISSIONED COAL-FIRED POWER STATION MADE FAMOUS ON THE COVER OF PINK FLOYD'S ALBUM *ANIMALS*

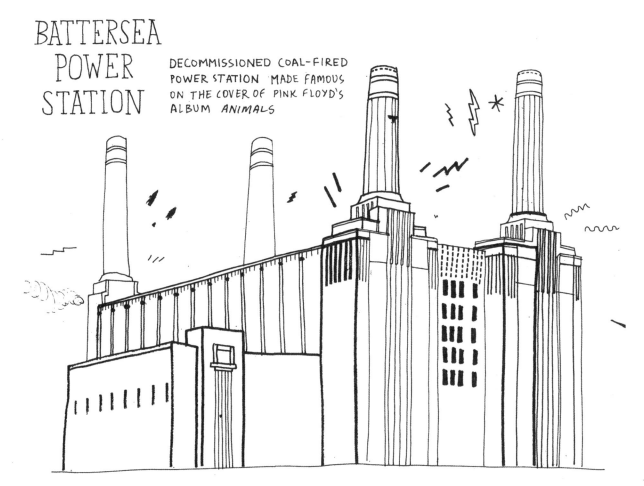

초판 1쇄 발행 2018년 08월 25일

지은이 | 제임스 걸리버 핸콕
옮긴이 | 김문주
발행인 | 홍경숙
발행처 | 책발전소

경영총괄 | 안경찬
기획편집 | 김효단

출판등록 | 2008년 5월 2일 제2008-000221호
주소 | 서울 마포구 토정로 222, 201호 (한국출판콘텐츠센터)
주문전화 | 02-325-8901

표지 디자인 | 김종민
본문 디자인 | 김종민
지업사 | 월드페이퍼
인쇄 | 영신문화사

ISBN 979-11-89352-00-4 14650

* 책발전소는 위너스북의 실용 · 인문 브랜드입니다.
* 책값은 뒤표지에 있습니다.
* 잘못된 책이나 파손된 책은 구입하신 서점에서 교환해 드립니다.
* 위너스북에서는 출판을 원하시는 분, 좋은 출판 아이디어를 갖고 계신 분들의 문의를 기다리고 있습니다.
winnersbook@naver.com | Tel 02)325-8901